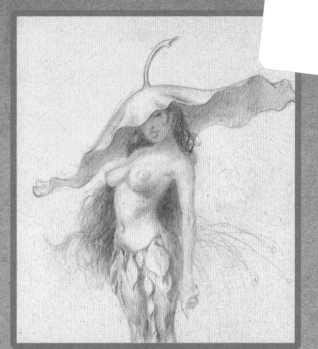

THE ART OF CRAIG ELLIOTT

For Mom, Gammy, Grams, Aunt Suzan and Aunt Juanita
—Women of inspiration

Introduction: Iain McCaig

Foreword: John Fleskes

Writing, design and layout: Craig Elliott

Additional writing and editing: Laura West

Copy editor: Martin Timins

Special thanks to: Jackie Huang

Designed by Craig Elliott.
Copy Edited by John Fleskes, Martin Timins and Laura West.

First Printing
January 2012

ISBN: 978-1-933865-39-3

Flesk Publications™
www.fleskpublications.com
info@fleskpublications.com

Craig Elliott
www.craigelliottgallery.com
www.craigelliottcollection.com

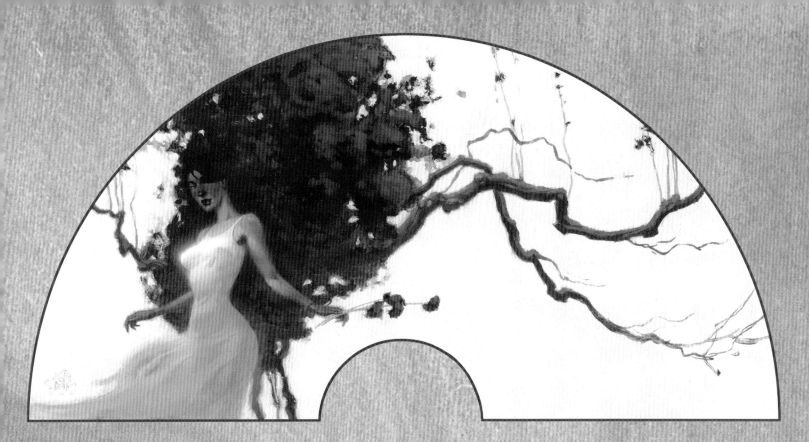

CONTENTS

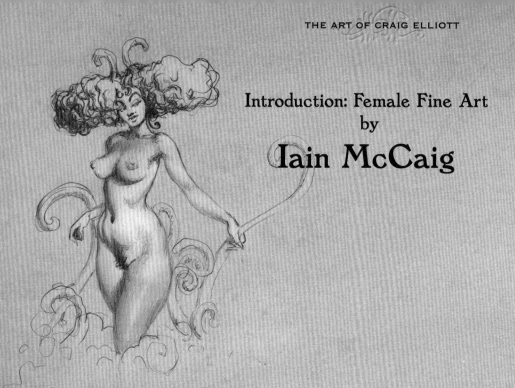

Introduction: Female Fine Art
by
Iain McCaig

The Muse watches the Artist stumble down a lane between the trees.

"Where are you going?" she asks.

The Artist raises his head, looks around. For some reason, he can't seem to see her. Why are artists always so blind?

"I'm over here," she says. Then suddenly, she isn't. No sense making it too easy for him.

The Artist smiles, becomes fascinated by breastlike burls on a tree. He pulls out a small sketchpad and begins to draw, caressing the curves with his graphite stub, remembering the day he discovered, to his eternal amazement, that girls were different from boys.

The Muse holds the pose for a while—it is easy to look like a tree—but the Artist is so slow that she shifts again. The gleam falls from the Artist's eyes. He sighs. "I should go now," he says. "There's somebody waiting."

"But you've only just got here!" the Muse says and laughs. Well, if he's going to give up that easily...she leaps in front of him, now a Maiden of the Forest, red hair blazing on pink, well-scrubbed skin. Two identical maidens pirouette from between the birches, their dance stirring autumn leaves thick as tomato soup.

Just then, a vast shadow falls from above. The Artist is gripped with fever, cold sweats, heartache. He drops his pencil and paper and grabs his head, fingers digging into flesh. The forest shakes.

The Artist weeps.

A green dragon lies under the canopy of trees, majestic, broken. Red leaves drip from the air onto his skin. All three Maidens of the Forest speed to his side, mingling their breath with his. The old God of the Skies shivers once. Dies.

The Artist can't find his pencil and paper. Desperate, he claws bark from a birch and draws the scene with his own blood. The dragon is going back into the earth. The Artist knows better than most that life is always hanging by a thread, so easily cut. It is fragile, even for a mighty dragon.

He can't stop crying.

When it is done, the Artist lifts his eyes from his drawing. In front of him stands a convention center and a young man staring goggle-eyed at the image of three Maidens, bums like barn doors, gathered round a green phallic snake-thing.

The Artist hands the drawing to the boy, tearing out another piece of his heart.

The boy's hand shakes as he takes it. For just a moment, the Artist hopes that he understands.

Reverently, the boy hands the drawing back to the Artist.

"You forgot to sign it," he says.

Craig Elliott is a Fine Artist, and a fine artist. He wears both titles modestly. He is not a loud person. Not the kind you'd notice right away. His eyes burn right through you from time to time, but you can always look the other way.

I first met Craig at the home of mutual a friend, David Krentz. We chatted about this and that, sitting between a bronze Tyrannosaurus rex and a blackened suit of armor. I learned that Craig had had a brain tumor, one that robbed him of his ability to produce his own hormones. It also played havoc with his sight, starting with his peripheral vision, which turned gray and fuzzy. Contrast blew out, like a picture run through an old photocopier. Colors began to leach away, so that his student paintings had way too much red in them, to make up for seeing less. Somehow, Craig and his sight survived, though he lives now only through the grace of miracle medicines and the hope that supplies don't run out. I wondered what Craig does. Something in the film industry, I knew, but there are many somethings in the film industry.

David had just bought a big print from Craig for his wife, Kim—something called *Jade*— and he takes us into the spare room to show it off. Politely, I follow. I had Craig pegged for a newbie, but I liked him and got ready to offer some encouragement and advice about breaking into the film industry and how to compensate for painting too much red.

You can recreate what happened next for yourself. Flip to page 28, close your eyes. Hold the book really close (it was a BIG print). Now open your eyes.

I don't think I said anything, at least nothing with consonants in it. Craig shyly asked if I would like to see his portfolio—he had it online on David's computer screen.

Gobsmacked, I dove into the portfolio, and headfirst into a golden land.

Nymphs wriggled from the pixels and pilfered my heart, making me laugh as boyish fantasies were made flesh, vulgar and innocent as pinups. Landscapes rolled across the screen as spare and clean as haikus, their colors mouthwatering fresh. I felt like a kid again, everything a discovery. I had fallen through a peephole into Craig's world and had utterly no desire to ever leave.

The last image appeared, and I finally became aware of a subtler flavor, a whiff of farewells and sweet sorrows. I was about to head back to hunt it down when I heard a noise.

"Do you like them?" Craig asked, breaking the spell. His humbleness was real, almost Winnie the Pooh. I learned then that he was one of the principal designers on Disney's *Treasure Planet* and many other classics for many other studios. He was not a newbie.

CUT TO: many years later. Today.

This majestic little book that you hold in your hands is a portfolio of Craig's female fine art, collected over a period of 17 years.

Craig is still one of the humblest people on the planet. When he asked me to write this introduction, I got the feeling he was still waiting for me to tell him what I thought of his work.

Well, Craig, it's friggin' awesome.

Your draughtsmanship seems so second nature that I know you don't even think about it, your mind frolicking with your subject matter, as it should be. Your oil painting for *Never The Twain* (page 21) is paradoxically lavish and restrained, well-observed and wildly caricatured, lyrical and ready to explode—which is why I gave it my vote for a silver medal in *Spectrum 17*. And if you ever had a problem with color, it is more than cured; there is such beauty to your palette that my mouth waters. Particularly the color red.

As for you, dear reader, I trust you will enjoy your journeys through this magical land and your encounters with Craig's Muses and Maidens.

I know that, after all these years, I still do.

Iain McCaig
April 5th, 2011

Foreword: Connections
by
John Fleskes

It is easy to assume that the initial appeal of the art within this book is due solely to the female subjects. A first look proves they are voluptuous, sexy and beautiful. Their curved lines bear comparisons to the roads delighting the most extreme of motorists. However, a longer gaze will bring forth a deeper appreciation. These women are not powerful, dominating or fiercely independent. Nor are they timid or frail. They are grounded, loving, support each other and are confident. The way the figures are rendered, the response the artworks emit and a prevalent connection with nature highlight the individualism of each piece. Furthermore, the work's cohesiveness and variety is displayed through an invisible thread that ties this collection together. These are not your average women or your typical compositions and environments.

Craig Elliott obviously depicts his women in a beautiful fashion, but his renderings are not created to fulfill a male fantasy. He is careful never to marginalize women in any way. His choice of subject matter is a part of who he is. "Women and nature are my two favorite things and the most exciting things in the world that I love," confesses Craig. "I think there's an indescribable connection between nature and me. And I also see that connection with women and the rhythm of nature. Their bodily cycle is in tune with the moon, and their reproductive capabilities are more obvious and fine-tuned than ours. Male thinking is more anti-natural, and we want to take and adapt nature. Women want to enjoy it and accept it the way it is. They don't seem to need to change it like men do. I agree more in that way and relate to women more in that regard. I have more women friends and relate to them more than guys. There's a feminine aspect to me which explains why I am exploring the nature of women more than things like male subjects and barbarians." Craig's sympathy for women can be tied to his being raised solely by his mother, with no male siblings and few male role models.

There are certain body types that appeal to Craig, and his subjects often fall outside the type usually depicted in the Western media. "I think initially I'm both attracted to curvier women and can emphasize with them more," Craig admits. "This gets into my medical condition, because I was always so slender and weak. Being negatively treated as a frail man compares pretty equally to how a larger or average woman gets treated. They are marginalized and told to be the opposite of what they are. I grew up with criticism and being expected to be the physical opposite of what I was. Therefore I can relate to women who are being treated the same way. I found myself attracted to the opposite of what I was. It's the same kind of treatment being applied to a different group."

When Craig was 6 or maybe even younger—no one knows for sure—his health was seriously compromised by a slow-growing tumor. In addition to being thin and lacking in physical vigor, Craig suffered from a gradual loss of vision, as the tumor pressed against his pituitary gland and other essential structures in the region. Its eventual discovery and removal didn't come until his mid-twenties. While some victims would focus on the time lost with illness, Craig instead channeled this past hardship into expressions of beauty. And he can find beauty within any subject.

"Every stone, no matter what its shape, has its own beauty," declares Craig. "Even within those rocks that are marginalized and depressed, fighting for them is like fighting for myself. There's some justice to be done!" This topic is very personal to Craig, as he conquered his own insecurities from his youth through personal expression. And it is this feeling that resonates in his art, making it truly special. "That's what art's about," he says. "It has to be something to do with you or it's just about aping what you see out there."

Craig's beliefs make his art very personal. He champions the unglamorous in an elegant way. He is spreading the message of how archaic it is to judge and mistreat people whose body types might not conform to a common perception of perfection. "A theme in my work is trying to get my head around current social norms that don't serve us anymore or are detrimental to us," he explains. "Their value is also so small because of how fleeting and mercurial they are in the span of human history. For example, having to be a certain weight at a certain age has changed so frequently throughout time that it is meaningless. There is no basis in biology, and there is no reason to deride or reject someone who doesn't fit. I noticed recently that I overemphasize the curvy girls, and I am now trying to make all kinds of girls acceptable. I should stand up for skinny girls too. I don't want to leave them out. I want to include a wider variety of bodies to emphasize more the acceptance of all types." Craig's hope is that, through his art, people will see that there is no "ideal woman." There are many shapes and sizes, and they are all beautiful.

Inventing new things also holds great interest to Craig. His ingenuity is utilized often through his freelance work as a visual-development artist. Two recent films he contributed to are *The Princess and the Frog* for Disney and *Rio* for Blue Sky. But his inventiveness is not just reserved for his clients. His own passion must be fed. The desire for expression has also led to his personal line of fine jewelry. "The Craig Elliott Collection" infuses his passion for nature into intricate organic designs. A range of collections and styles feature earrings, bracelets and necklaces, each designed with the same depth of creativity that is found in his drawn works. But first his imagination needed to be cultivated to reach the point where he is today. The foundation for his approach was cemented through higher learning.

Looking, Graphite on paper, 2010

Craig was a student of the late Burne Hogarth at the Art Center College of Design in Pasadena, California, for approximately 30 weeks. He had a mild awareness of Hogarth before his first class, mostly through his instructional books, but was not familiar with his comics work. (Hogarth gained much notoriety for drawing the *Tarzan* Sunday newspaper strip from 1937 to 1950.) Craig found Hogarth to be both funny and smart. He proved a good teacher by inspiring Craig as much philosophically as through his art. "He would talk about his ideas, philosophy, about life, and about the origins of words," remembers Craig. "He spoke of evolution and pointed out how variations in body types were a result of different peoples adapting to their environment." Hogarth was very interested in physiognomy. He shared his studies and knowledge with his students regarding the variations of eyes, noses and other features that differ based on the region an individual comes from. "He knew a lot about ancient religion and cultures," continues Craig. "He would bring all that stuff to bear in class along with the nuts and bolts of anatomy and drawing." Hogarth's curiosity of more than just art, but also people and cultures, fit well with Craig's inquisitive mind. It allowed him more confidence in exploring the many subjects he would later paint. "I read a comment by Frank Frazetta saying that Hogarth thinks too much," recalls Craig. "I agree that you can overthink things, but Hogarth's mind was so powerful and he kept himself entertained by questioning things, and that is who he was. His intellectual curiosity was inspiring, and it is okay to think and be curious, and that is a good thing to freely explore and think about things." Through Hogarth, Craig learned that an artist can be free-spirited as well as educated and analytical.

In observing Craig's art, it is evident that there is a definite construction to his works that does not fall within conventional boundaries. There are differences between his works that keep them from becoming a cliché and make each fresh and exciting. A book collection like this can be detrimental in quickly pointing out the flaws in an artist's work, as repetitious ideas and compositions can become highlighted. In Craig's case, the variations are spotlighted. There are typical structures available to replicate, yet Craig tends to find unique ways to construct, design and harmonize. He is more interested in constructing things from scratch rather than using blueprints. "It is something that I try to do," he explains. "I don't expect your average person to necessarily be able to verbalize it, but I want them to feel that originality and know that something different is going on."

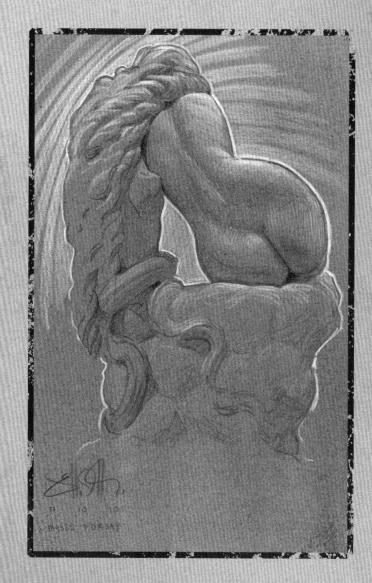

An artist is often asked who his inspirations are. In Craig's case, the answer is not available by looking at his art. Craig does not care for the term "inspirations," since he is not trying to emulate another person's style. Instead he prefers to look at the works of an individual he finds he can learn from. And he is not one for placing himself into a category, a label or a group of artists. This isn't out of an inflated ego but actually more of a goal to be unique.

Still, one artist has given him much insight into being creative. "One of my favorite artists is Roger Dean," Craig admits. "I've always been impressed by his work. I'm always trying to better understand his philosophy and approaches and how he squeezes things out of this imagination and how he builds new things. I learn a lot about how to invent and use my imagination from him, but I don't try to mimic his work. I view his work to try to break down his philosophy and see how I can use it to build worlds of my own."

Another of Craig's favorite instructors at the Art Center College of Design was Harry Carmean, who taught him how to learn from existing art without witnessing the process. "I can look at a painting and see what is a good structure and content," he explains. Craig takes the elements that intrigue him, then deconstructs the art to obtain any information that can benefit his own approach. He is looking for how the person is pushing his own concepts further and how the structure of his art works. "There are lots of things that make good art, and artists know it," adds Craig. "If you know how to find it, you can learn a lot." A comparison can be made with the engineering of a bridge. You can view the beams on the outside, then study the structure and mechanics to see how it holds up over time. You can see how to improve the makeup, increase the strength and add to the aesthetics. You can study why one particular span holds up better than another. Then it is possible to apply it to your own work. "I don't copy an artist's style," Craig stresses. "But I wonder what is he doing and how is he building these things at a basic level? How can I use these tools to make something for me?"

The construction of a work of art is more inspiring to Craig than the style. "That's a big thing for me and my art," he begins. "Edgar Degas [French impressionist artist, 1834-1917] would give himself a problem by doing something he's not supposed to do. Then he would

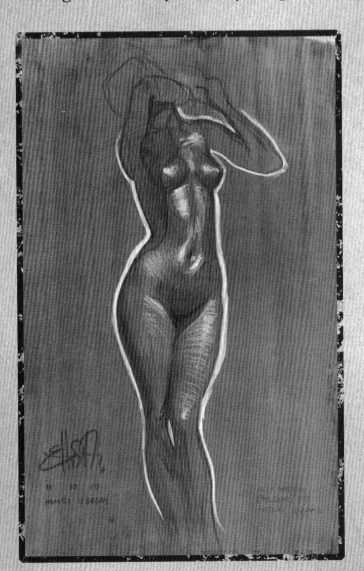

make that darn thing work even if it took five attempts at the same painting. That's the challenge and the fun, and it takes a good artist to be able to balance and get it to work." Craig will sketch a figure in an odd location or send the eye off the page and then work out how to make the composition succeed. "I love the sense of wonder that unusual compositions create," he says.

Understanding the building blocks and making art personal are two things Craig stresses. It is extracting the works from within yourself not basing it on what you think others want to see that is crucial to expressing yourself fully. The reactions from admirers are secondary to Craig's need for self-satisfaction. "I want to make things that *I* want to see," declares Craig. It is this self-assurance that drives him. If he created the work to satisfy himself first and foremost, any outside criticism is not going to stymie him. Craig has a yearning for individuality.

Craig believes that without your own style, you can't create something truly original. "As an artist, I try to come up with something interesting and new and have all the things I like in it," he explains. "I try to deconstruct myself down to the most basic elements of the things I like about myself, such as when I was a child. I look at the activities I came back to, places I liked being in, and then I sweep them in a big pile and form those elements I see." This process allows Craig to look deep within his experiences to search for an expression.

He learned how to be imaginative rather than a mimic or slave to a certain approach. Interestingly, Craig has the ability to jump between styles for different assignments should the need arise. At times, as a visual-development artist for a film, he is asked to fit within a certain mold for a movie. With his training, approach and creativity combined Craig is equally adept at fitting in with an already determined look or coming up with new styles depending on what is required of him.

With his personal fine art, Craig follows his own rules, whatever they may be at the time. This allows him to express himself on his own terms, something that is necessary for him as an artist. As much as he enjoys working in film, "There's an itch that needs to be scratched, and these paintings fulfill that," explains Craig. "When you think about an artist, it is someone who does whatever he wants to do. Some artists can't do that, and I have a hard time understanding why not. That is foreign to me."

Craig feels limited when solely using the real world for inspiration. His initial sketches and concepts are plucked purely from his imagination. This is a conscious decision to keep the imagery purely his own. Models and reference are occasionally used, but only when a specific facial likeness is required or when a certain body shape can help fuel his work. Typically, though, he prefers to stick to his imagination.

Once he had amassed a reasonable amount of his fine art, Craig began exhibiting at Comic-Con International in San Diego. Up until that time, his personal art had not had a venue for viewing. He also began to sell prints, allowing people to take home their favorite imagery. Craig began to receive direct feedback, and a regular following of admirers began to grow. A common reaction he observed came in the form of a "feeling" not easily expressed into words by the onlooker. This response, while flattering, does not come as a complete surprise. "As artists, we intentionally put things in there to make you feel a certain way," explains Craig.

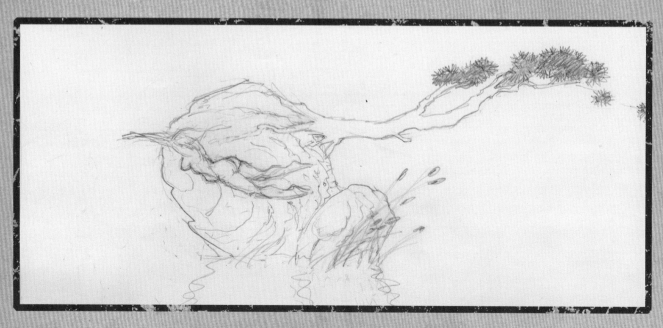

Leap, Graphite on paper, 2010

Compositional sketch for *Caryatid Path*, Graphite on paper, 2008

One example of a piece that brought forth a positive sensation from the author of this essay is "Caryatid Path." Curiosity rose, regarding not only the piece but also Craig's story behind the image.

A caryatid is typically a draped woman supporting a column. A support theme is hinted at with the title. The focus is on three female figures in a unique placement. Their actual presence on the canvas is small. The center and main canvas area are covered with the green hues of nature, with the ground elements of living wood. Yet they are all intertwined to make a whole. Each element has a relationship with another to carry the eye and keep you from getting lost. The red hair of the women echoes the fallen leaves and creates paths to one another, providing a harmonious arrangement. The women's legs are streamlined and pointy at the feet, almost digging into the earth as roots from a tree. The feeling was there, but the story was elusive. A call to Craig to discuss the piece revealed the following:

"The idea behind this piece is to express the admiration for women in how they support each other," Craig explains. "The column reference in the title, the 'Caryatid Path,' is the one women take together in support of each other. Each one that is supporting the next one is not necessarily connected. They can support each other from across the world.

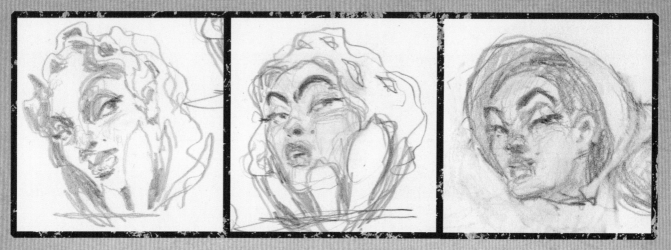

Alternate border head studies for *Caryatid Path*, Graphite on paper, 2008

"It's not just a physical and verbal soothing. The main figure glows and is magically supported by the women behind her. That is why the piece is darker and more somber so that the orange flowers that represent hope are emphasized. The path to hope is what she is trying to walk, and that is what these women are helping to do."

And what about the streamlined legs and pointy feet? "That treatment of the legs and feet creates more of a connection with nature and builds stability and grounds the figures so they don't feel like they are floating," answers Craig. "Some paintings seem like the characters float and are not standing on a surface. These approaches that I used were intended to create a harmony of colors and emphasize the message of support and transfer of power between the women."

The final element of Craig's works is perhaps the most obvious yet requires the deeper understanding of his art and technique. This is his arresting use of color. Craig has an exceptional understanding of which colors can create harmony on canvas. He manipulates the placement of color with the precision of a master craftsman while making sure his colors are fluid and have life. His colors convey mood, atmosphere and emotions and set the stage for a response, all of which are carefully worked out by Craig in advance.

Women, nature, the connection they have with one another, structure, story, color and a personal expression of the artist: These are the ingredients that prevail through *The Art of Craig Elliott*.

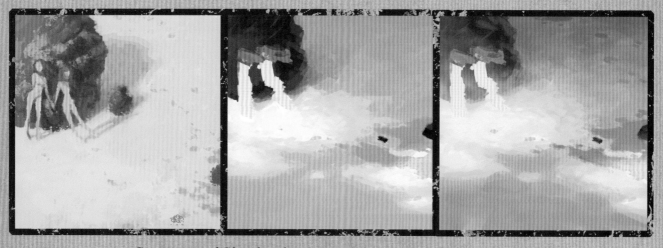

Compositional Sketches for *Caryatid Path*, Digital, Photoshop, 2008

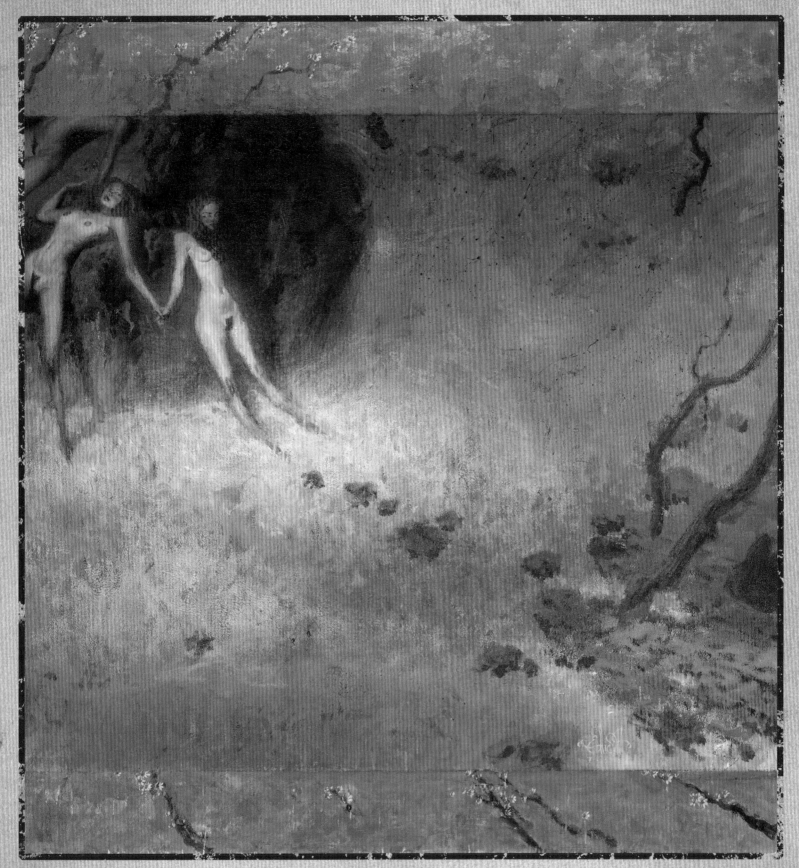

Caryatid Path, Acrylic and oil on wood panel, 36" x 36", 2008

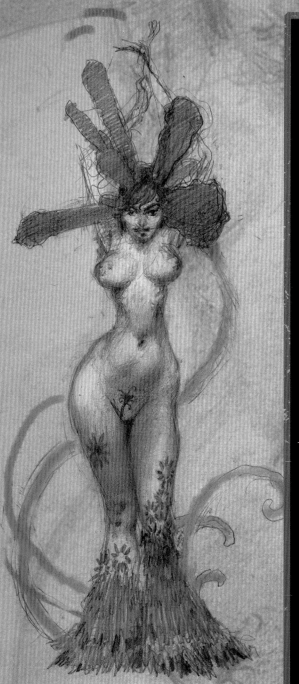

Sketch
Graphite on paper, 4" x 7", 2008

Goddess of Fall

The light and hues of autumn saturate the Goddess. The leavings of the season found in the hollows of roots or floating down a stream are one with her body. She radiates the inner power of her season, bathing Nature in a feeling unique to fall itself.

I was trying to capture the light and feel of fall without showing a traditional autumn landscape at all. Without a context, I had to bring elements of fall into the piece and use the soft edges and cool tones of a harvesttime day to express the season.

Painted for the fall 2010 issue #03 of Vehicle magazine as a special pinup.

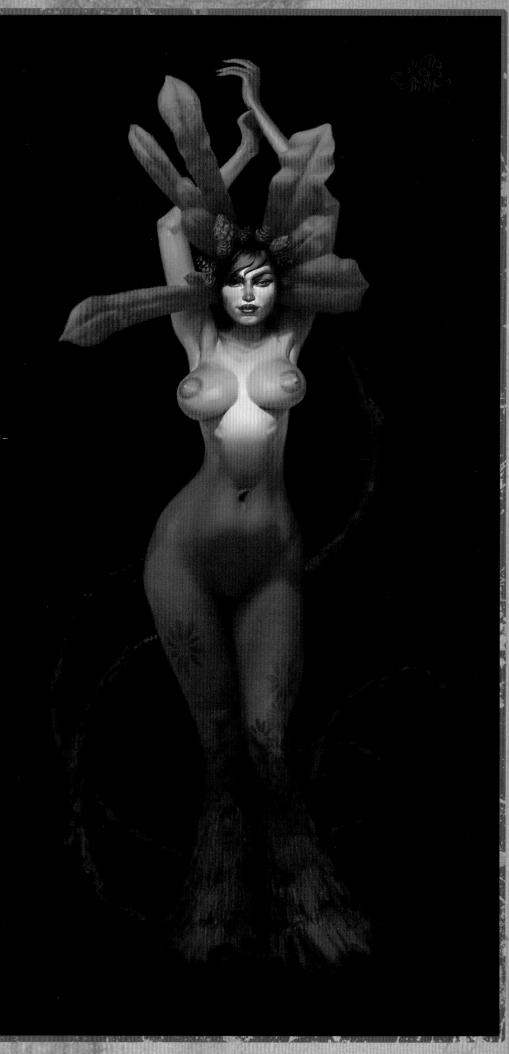

Goddess of Fall
Digital, Photoshop, 8.5" x 11", 400 DPI, 2009

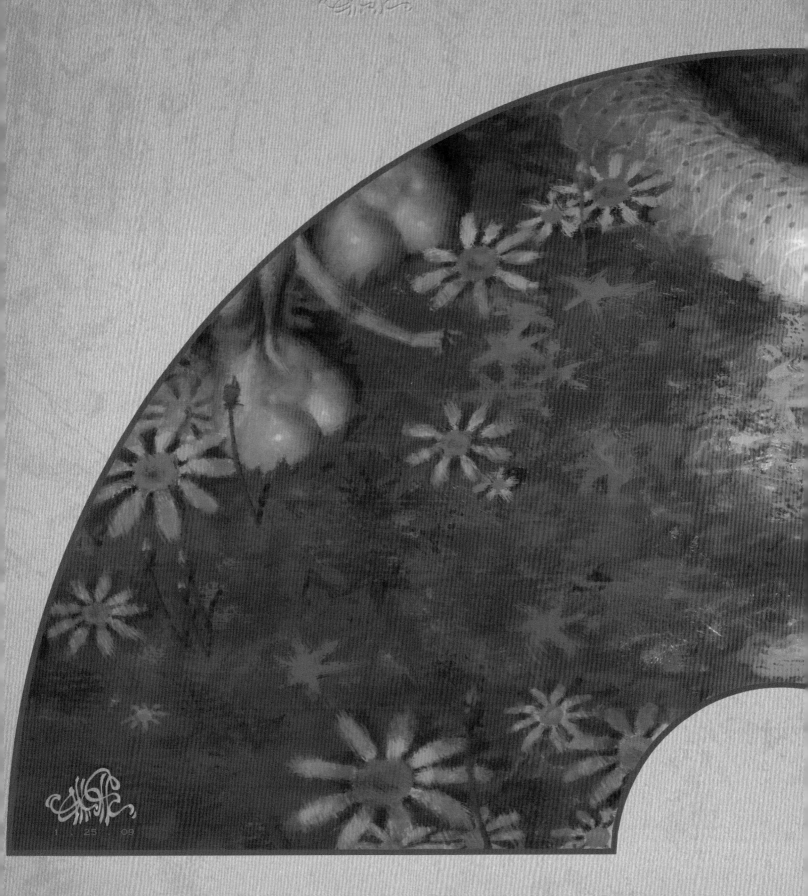

Dragon Funeral

The last rites of a much-loved dragon. The enchanted wood in which he lived is so rich, the forest floor is waist-deep in fallen leaves. The maidens of the forest attend this magical creature's passage into the next world and thank him for the time he has spent in this world with them. He will once again become part of the forest itself...

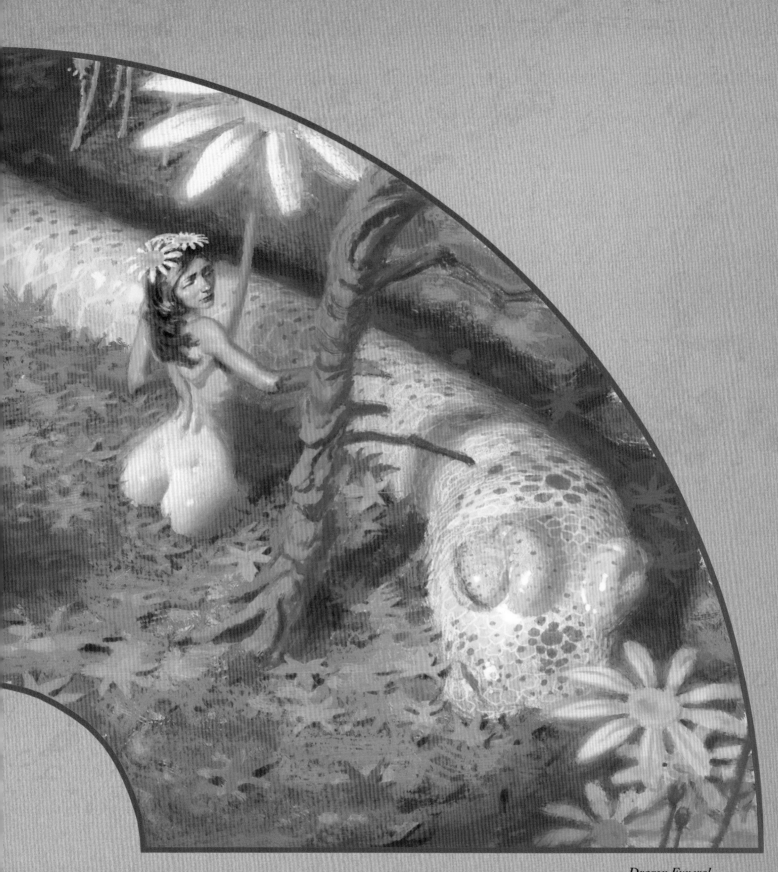

Dragon Funeral
Digital, Photoshop, 20" x 11", 400 DPI, 2009

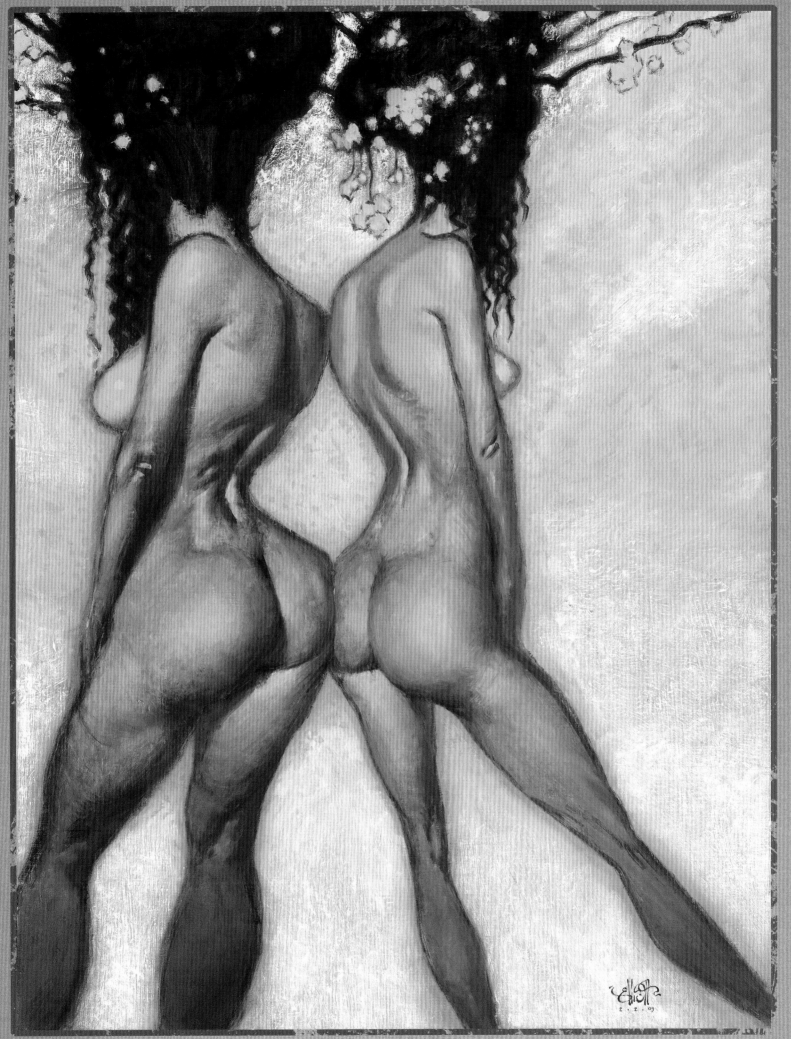

Never the Twain
Oil on Wood, 30" x 42", 2009

Tori Amos

A few years ago, I was approached by my fellow artist Ken Meyer Jr. to create an image for the *Tori Amos Calendar*. The calendar was meant to raise funds for Tori's RAINN charity to help victims of sexual abuse and violence. Myself and other artists were asked to paint our own interpretations of Tori and her music. I had never before known much of her music or story but was drawn into her world and inspired by her music right away. I produced many more paintings and had many more ideas. On these pages are some of the results.

Color Thumbnail
Digital, Photoshop, 4" x 5", 100 DPI, 2009

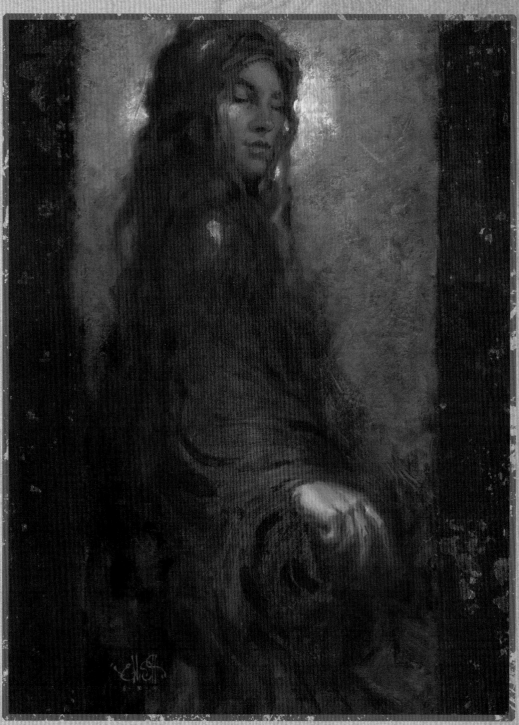

Divination
Oil and copper leaf on illustration board, 16" x 20", 2009

Divination

This painting is about the drawing of inspiration and creativity from all that is around and all that is within. This process results in an incredible transformation that often emerges through the hands back into the world from which it was drawn. Concentration, a sense of letting go are one at this moment of creation. All that has been learned about the craft is washed from the conscious mind and wielded instead by the unconscious at the bidding of the artist...

My approach to the technique of this painting—with a soft, diffuse background—is meant to reinforce the mysterious aspect of the creative process.

I was originally told the format would be vertical and was nearly done with this painting by the time the format was switched to horizontal. As a result, this painting was not used for the calendar.

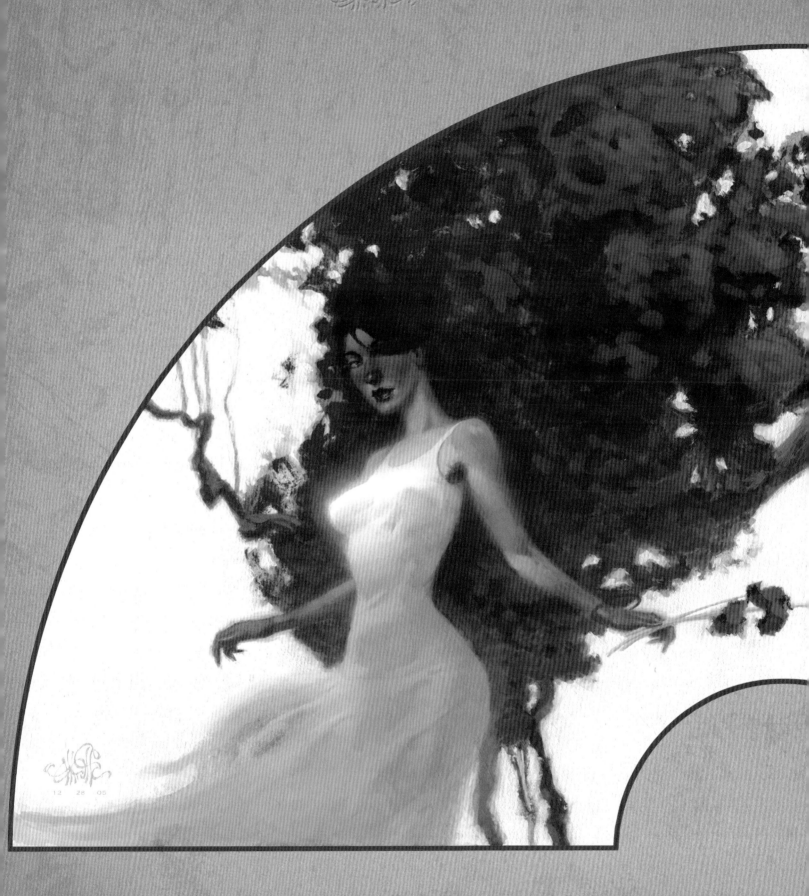

Tori Amos Fan

This design is the personification of a musical interlude, as the branches and flowers imitate the thread and play of musical notes. Tori Amos herself is woven into the music she represents here, as all artists are linked to their work...

The red hair and flowers take advantage of the "grouping effect" I learned from the work of Howard Pyle and Dean Cornwell.

Arguably my most popular print among fans of my work, this image has been seen on everything from clothing designs to coffee mugs.

Tori Amos Fan
Acrylic and oil on illustration board, 16" x 14"

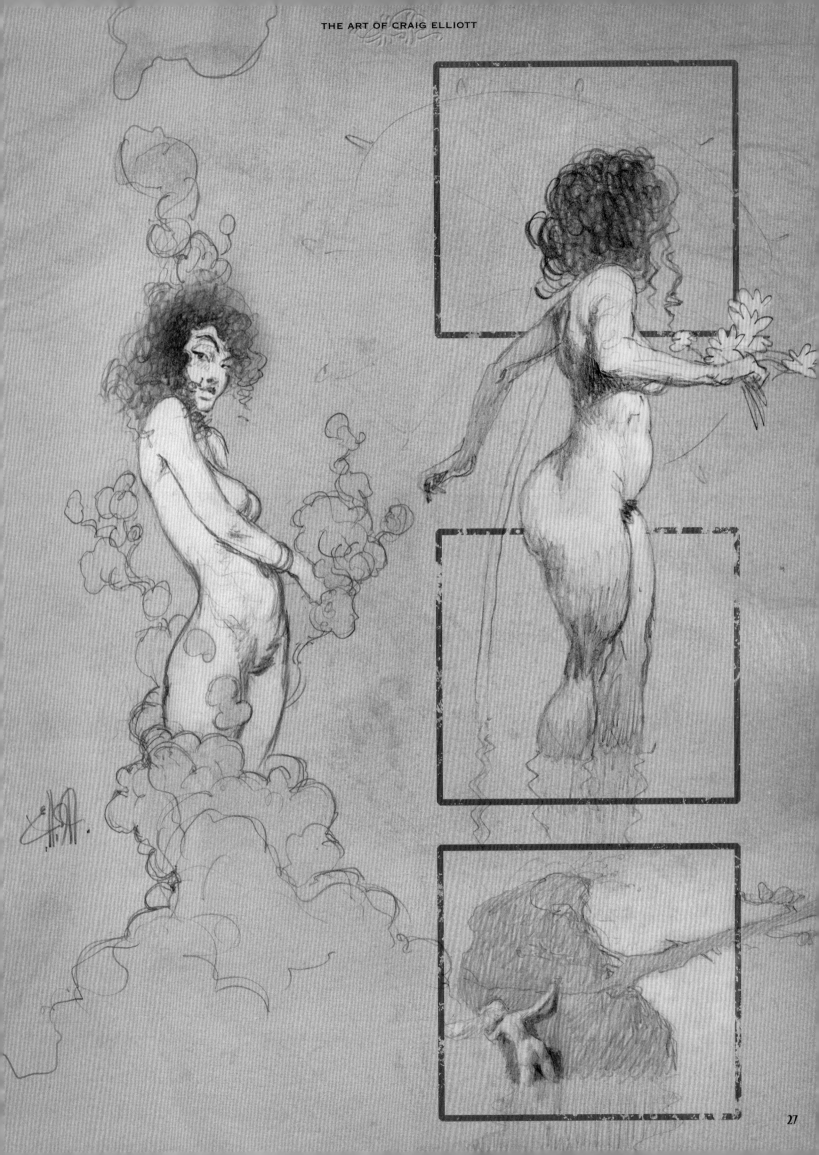

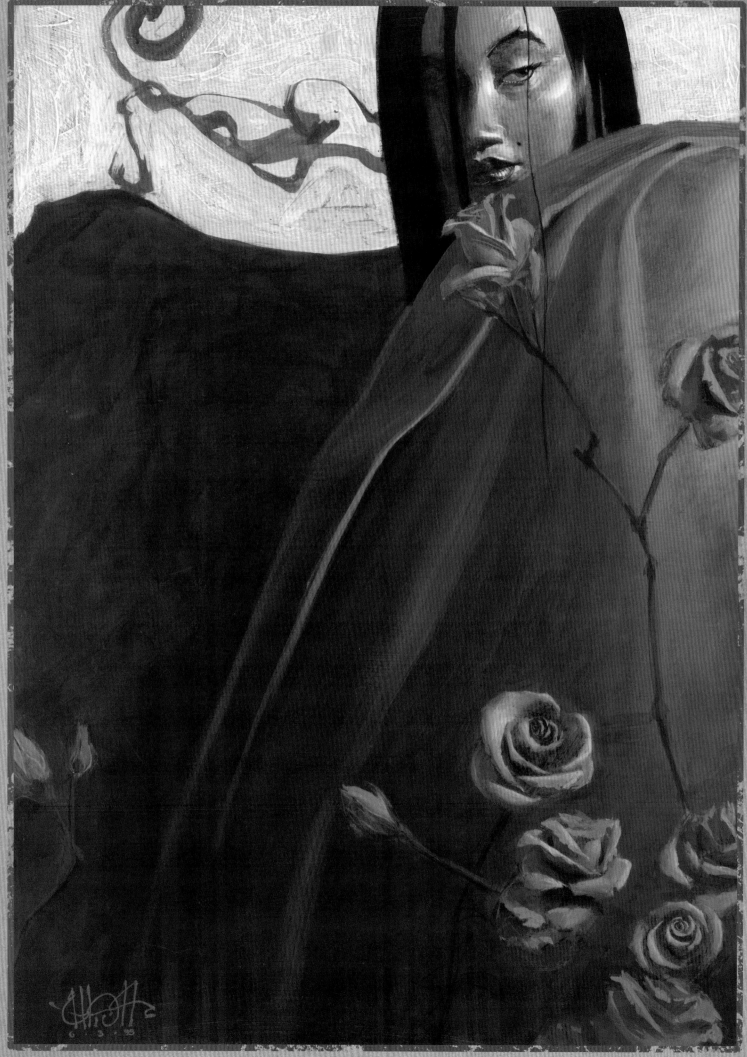

Jade
Acrylic on Rives BFK Paper, 18.5" x 25.5", 1995

Jade
(Facing Page)

The translucent misty-green stone of Asian legend transmuted into human form.

Jade is one of those "happy accidents" that sometimes happen to artists. I was working in my friend August Hall's studio, just experimenting with paint. The head, spiral ribbons and the sweep of the green coat just emerged from washes of acrylic. Later, August modeled for the green cape's folds and sweeps to help me add the final touch of realism.

This painting was a real breakthrough for me. I had long tried and studied to incorporate the radical balance found in Japanese woodblock prints and painting. I feel like this piece finally had what I was looking for. There is usually a gradual development of artwork into one's personal style, but on rare occasion a leap is made like this!

Jade was my second entry and acceptance into the *Spectrum 11* art annual in 2004.

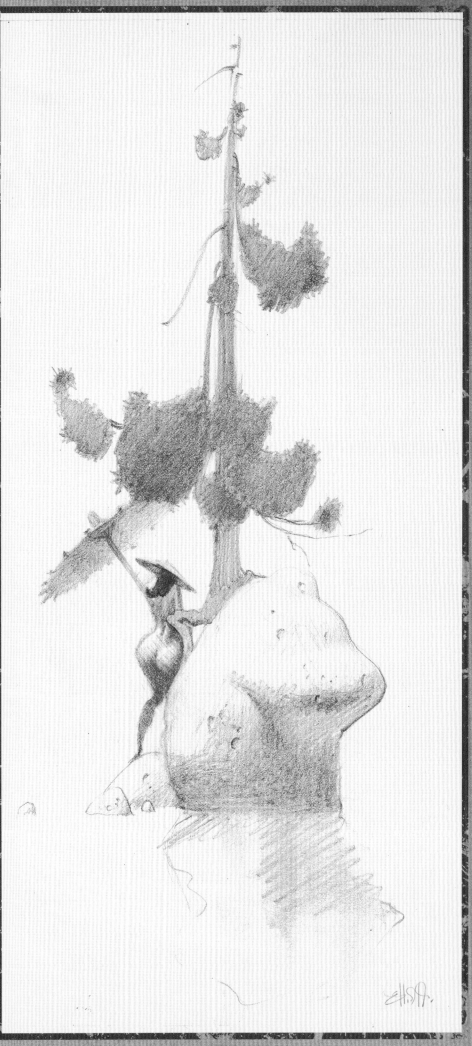

Pine Meditation
Graphite on paper, 4" x 11", 1992

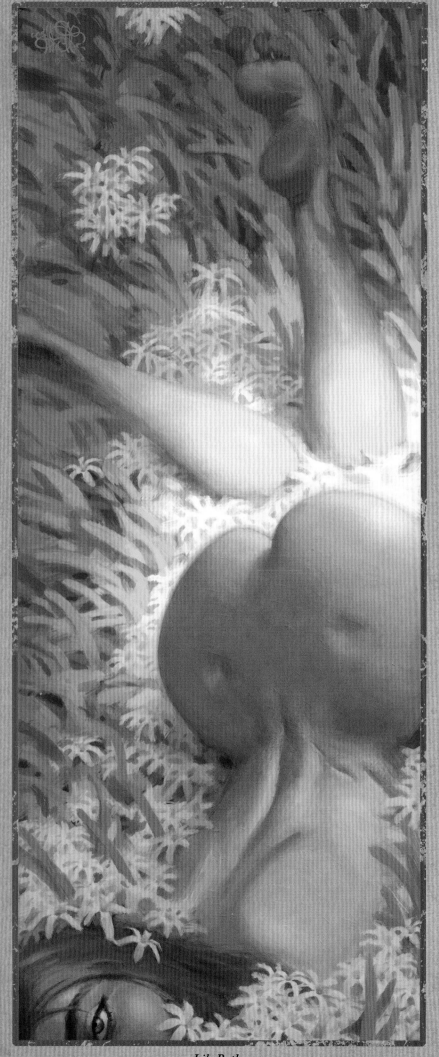

Lily Bath
Oil on wood, 25" x 16", 2006

Lily Bath

Sinking in as if merging with the forest floor, she is one with Nature itself. Imagine the fragrance and softness of the flowers as you melt into them...

Lily Bath was a painting a long time in coming. I got the original idea 12 years or so before the painting was started. Then the painting was left unfinished for several years because I had trouble getting the right angle on the body. The skin color on the woman was originally much darker, as if she were Latin or very tan. This did not look right, so she was repainted entirely as you see her here.

I very much like the radical composition of this painting. This is something I try to achieve as often as I can— pushing the limits of what I can do and still have the painting seem balanced. Degas is a big inspiration in this area for me. I am lucky to have the Norton Simon Museum nearby to peruse dozens of his works and study their compositions. Degas was a true master of composition who once said, "Painting is easy when you don't know how, but very difficult when you do." By this I always knew he meant composing paintings. If you know the history and elements of composition, it is much more difficult to innovate. You realize how hard all the great masters worked and studied to compose their art well. Keeping art fresh and new is important, and one of the best ways to do this is to further develop and push your compositions.

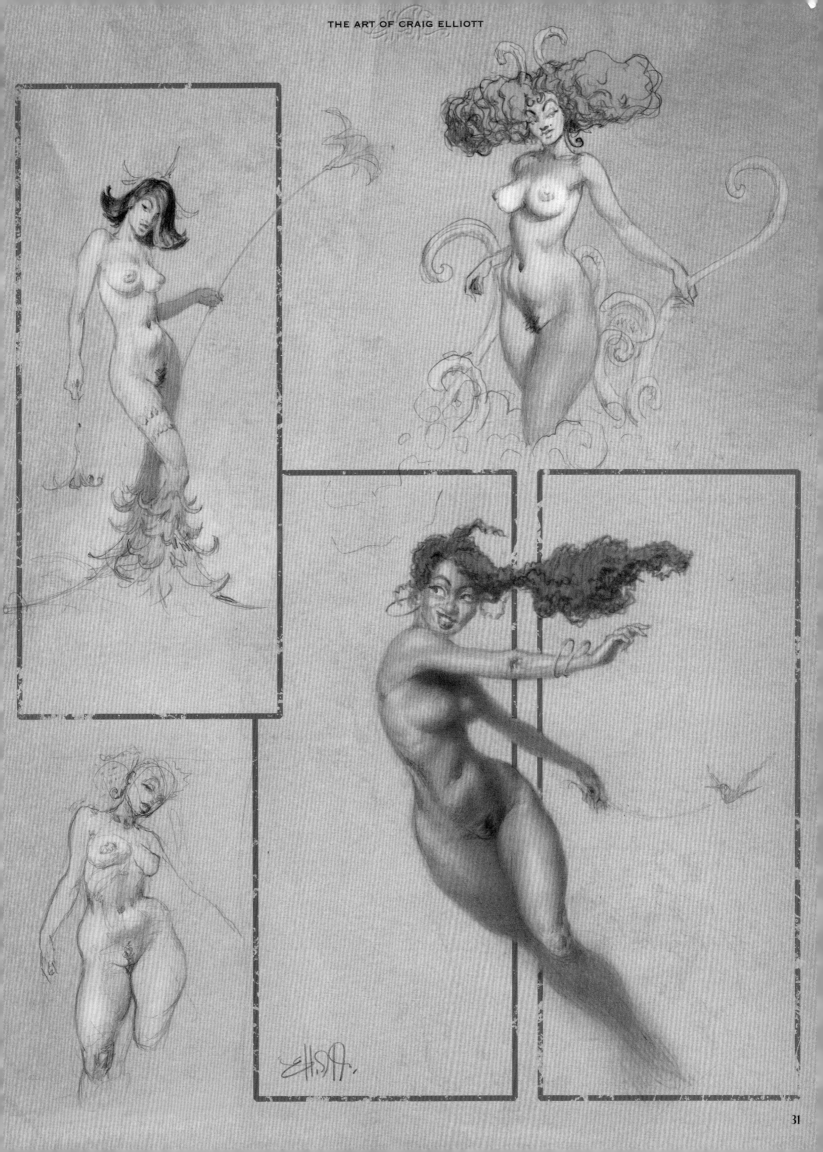

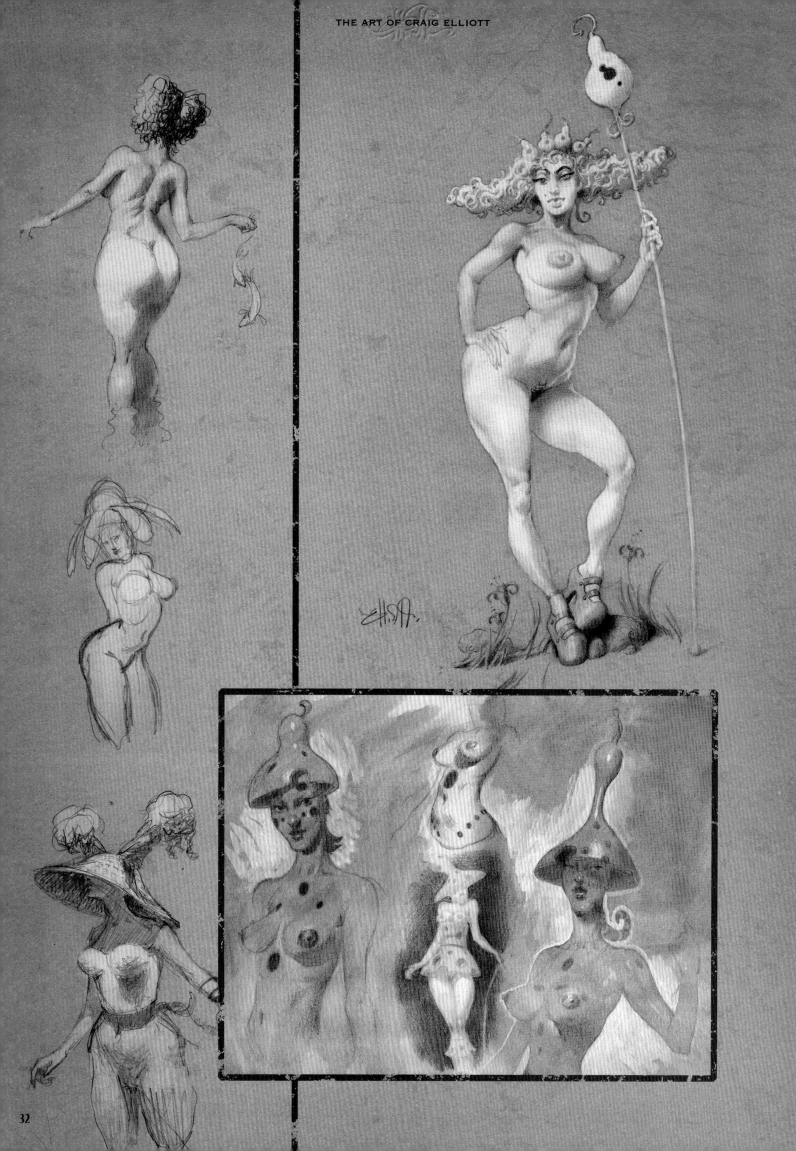

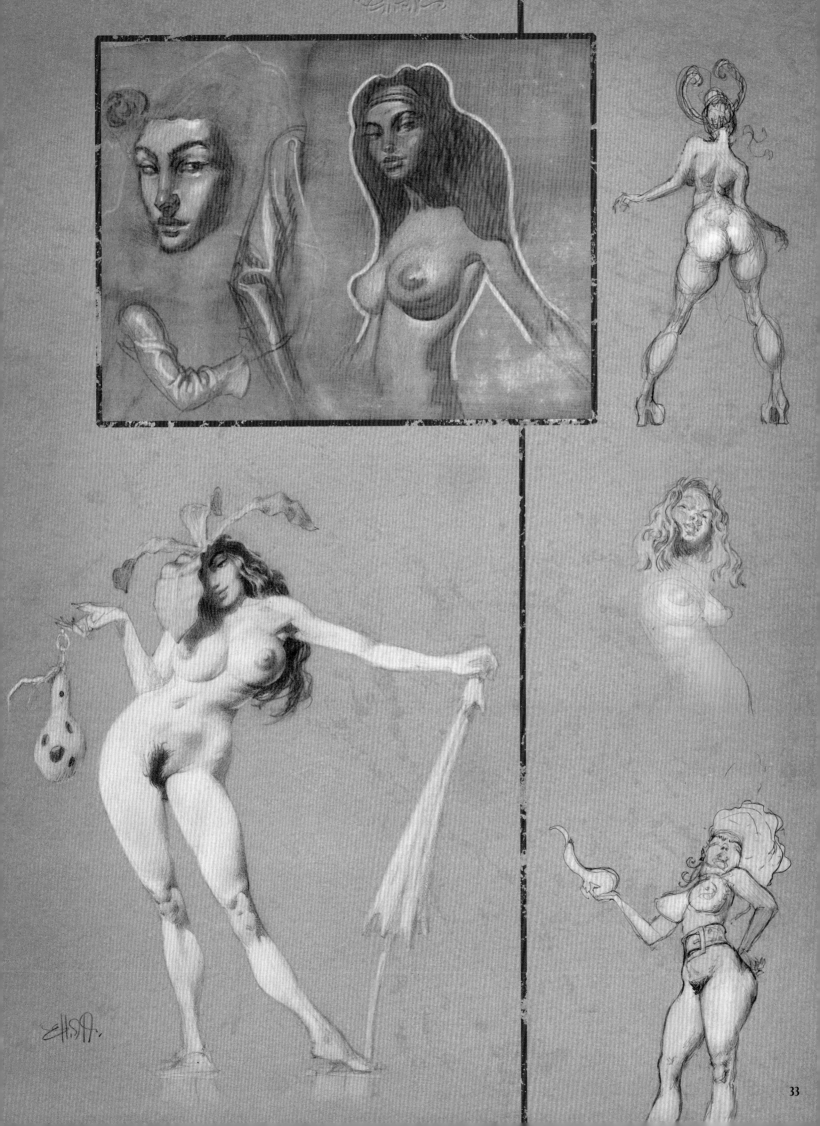

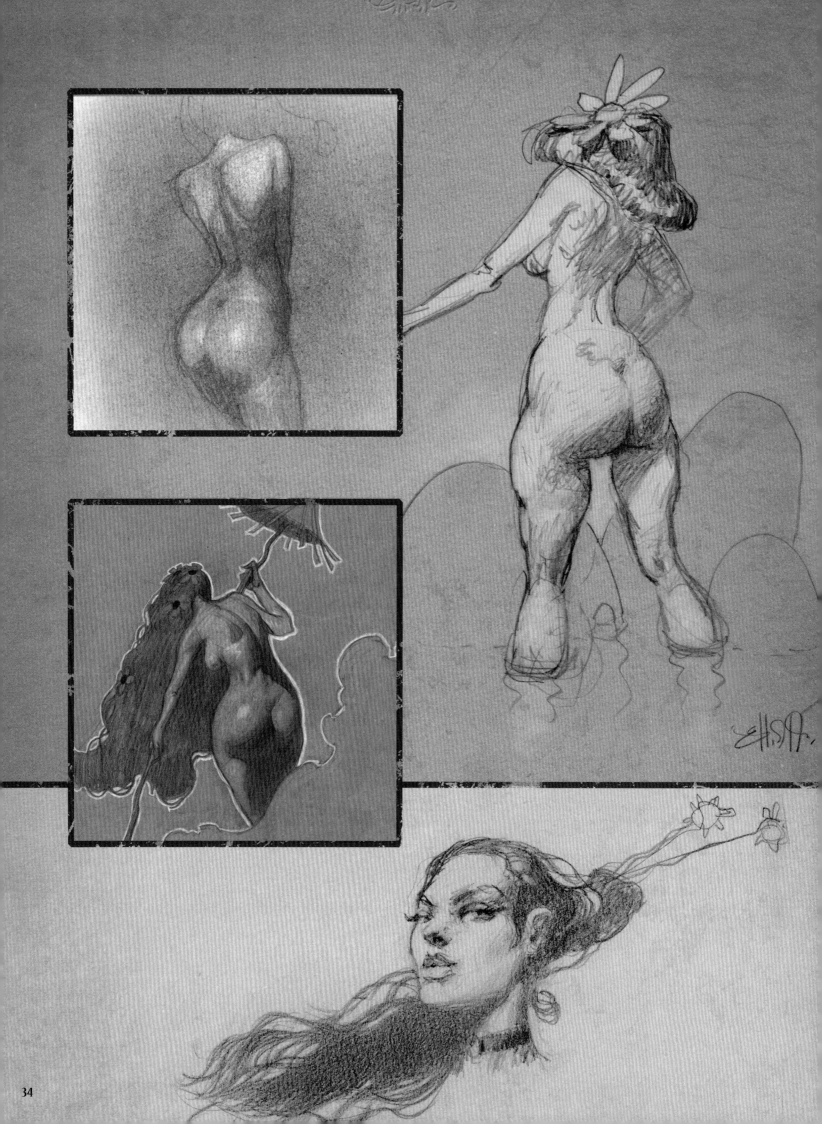

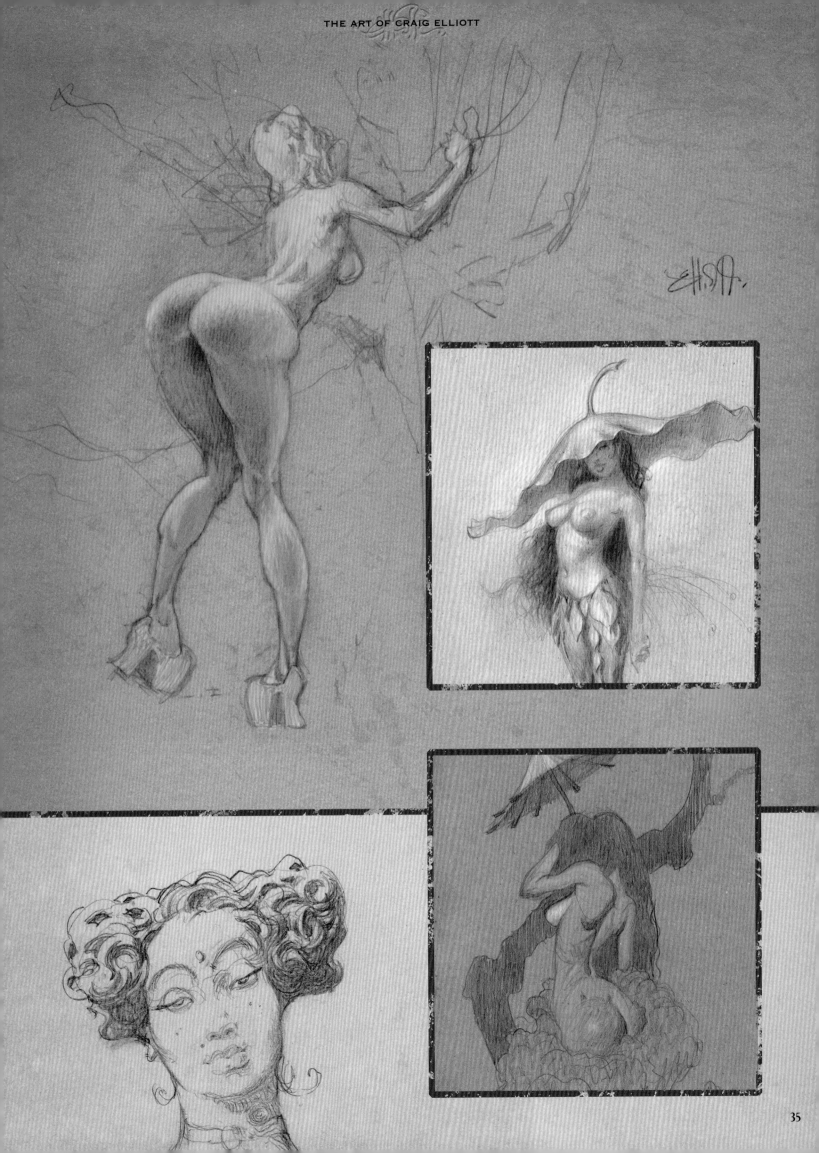

New Orleans Burlesque Poster

The *New Orleans Burlesque Poster* was a great opportunity for me to combine my love of design and painting the human form into one piece. I really enjoy the poster designs of 1900s Europe and started from there to develop this piece. New Orleans itself is steeped in design from that time period as well, so I feel this was a good place to start. My love of Nature and natural forms determined the shape language. Some iconic elements of New Orleans determined the actual objects in the picture. The fleur-de-lys, magnolias, iron railing detail and the state insect (the bee she is looking at) all relate to New Orleans or the state of Louisiana.

In addition to illustrating all the subjects I was asked to, I wanted to really capture the motion of dance and wry wit that is part of the burlesque experience. The wave of the skirt, the lift of the leg and the flip of the hair all create the motion and joy of a real moving dancer. The musicians are also designed to feel as if they were each making a note, one after the other in beat with the music. The center musician is a bit of a tribute to one of my favorite pinup artists and all-around great guy, the late Dave Stevens.

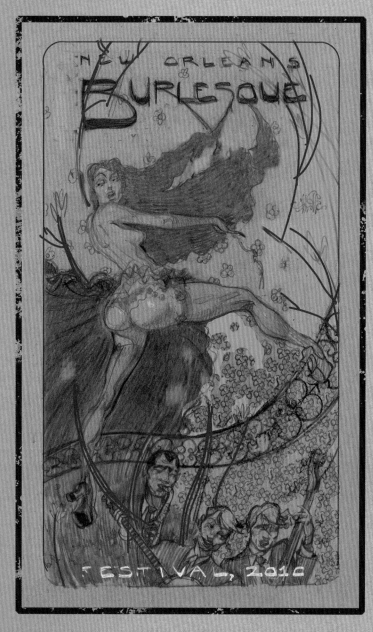

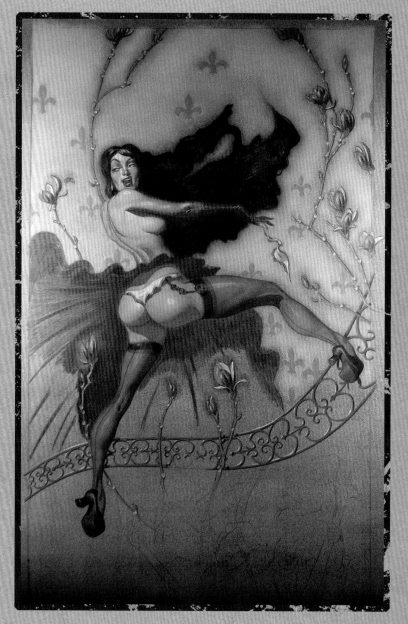

Poster preliminary sketch

The sketch chosen for this project was drawn before I was given the mandate to paint any specific dancer as the main subject. The show organizer got me in touch with a dancer in Los Angeles who would be in the show and he would like to be the model for the main figure on the poster. He sent me some photos of her, and I was blown away. She looked JUST like my drawing! The dancer, Evie Lovelle, came to the studio for a modeling session, and she was indeed a doppelganger for my original sketch. With a few photos and sketches, I was able to capture her likeness at the same angle as the original drawing.

Poster in progress

Here, Evie's features can be seen very clearly as the painting progresses. The differences are very subtle, but I am still amazed that I was able to capture the subject before I ever met her. This has actually happened once before with my painting *Judith I*. The *New Orleans Burlesque Poster* was first drawn to the extent possible with colored pencils on tinted Rives BFK paper. The larger areas and touch-ups were then painted in oils on top of the wax-based colored pencils. A final clear coat of archival varnish was sprayed on the piece to unify the surface sheen and pull the whole painting together.

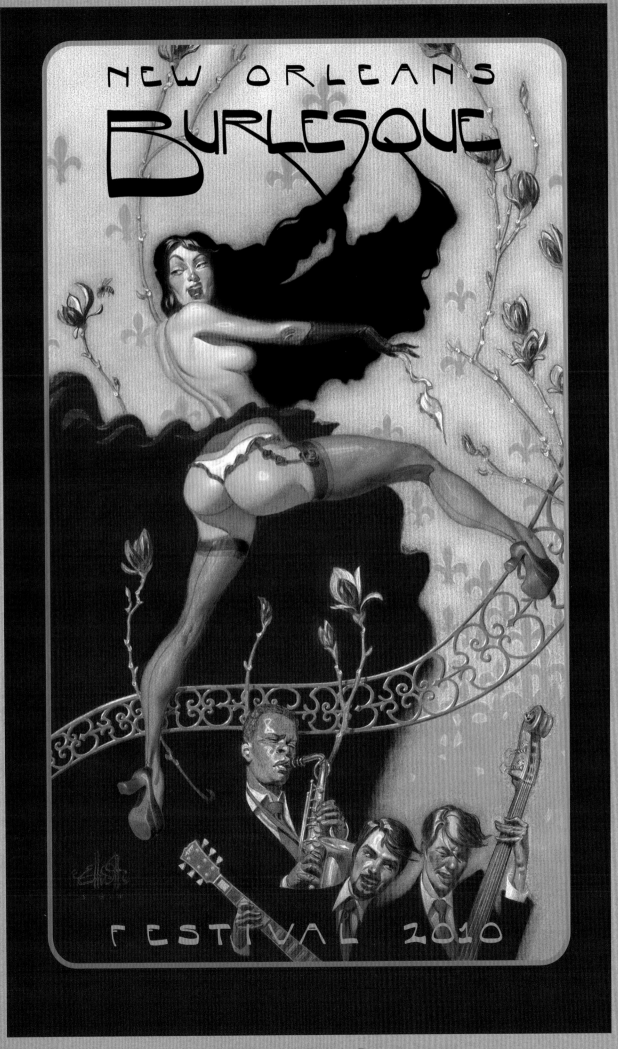

New Orleans Burlesque Poster
Pencil and oil on Rives BFK paper, 24" x 36", 2010

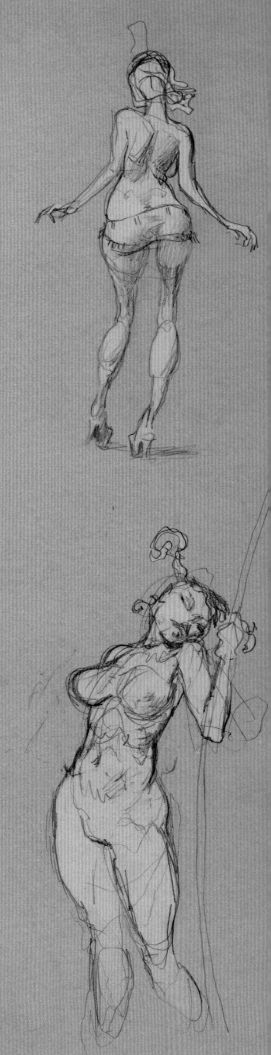

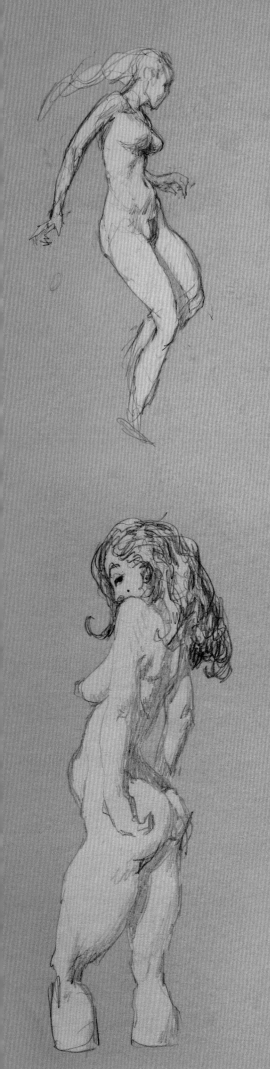

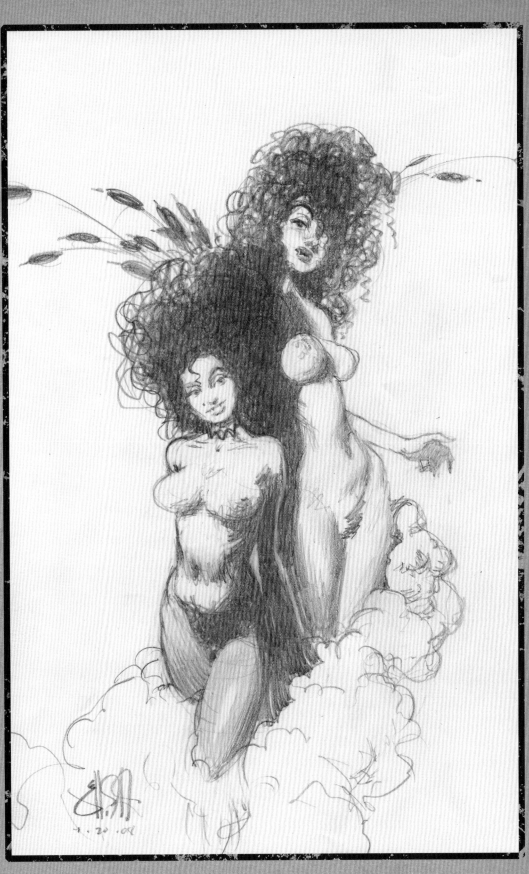

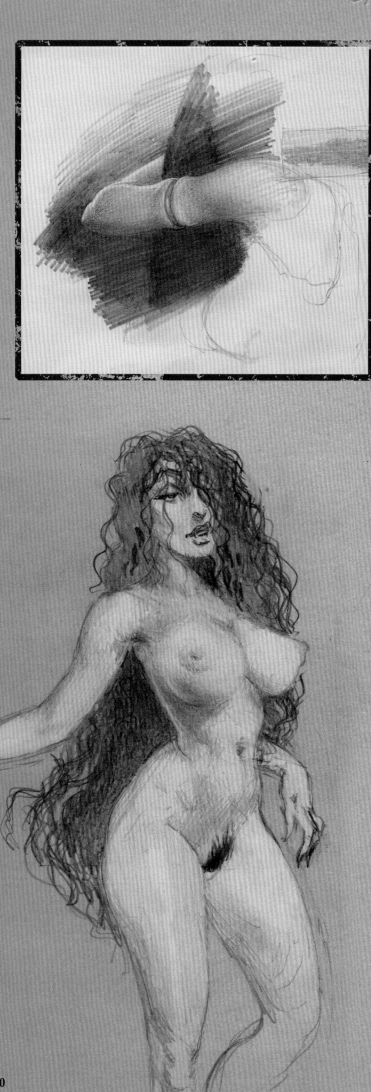

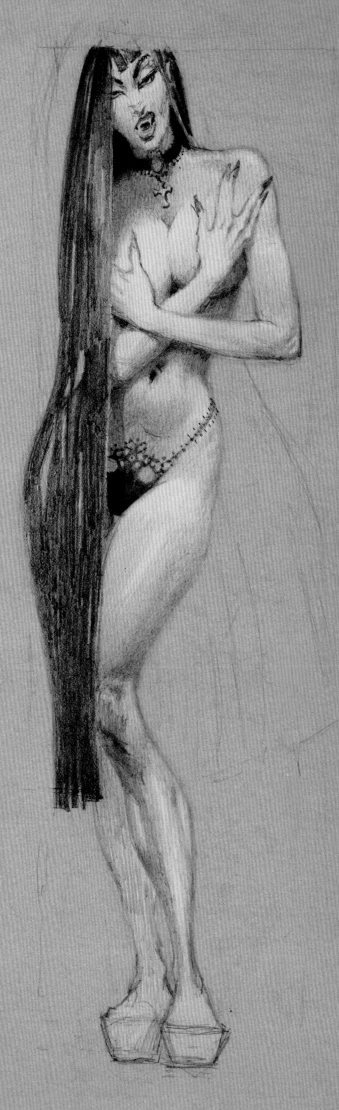

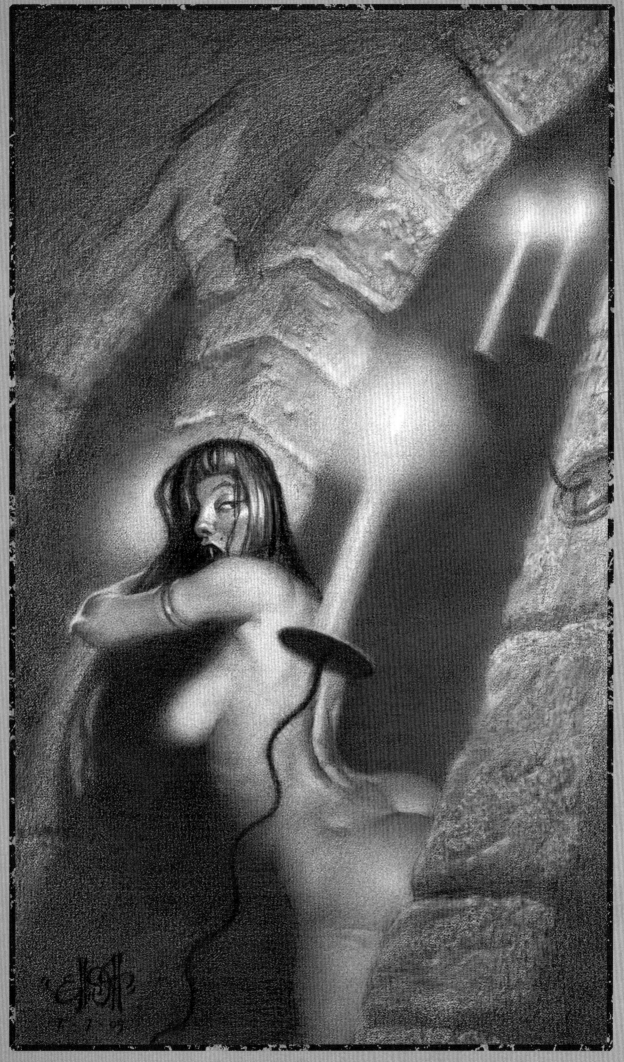

Fearful Vampiress
Graphite on rag paper, 12" x 22", 2009

Fishing Vampiresses

A rural yet sophisticated coven of vampiresses wade and languish in a cold swamp, far from human civilization. Fish and other swamp animals are the quarry of these women. This group of vampiresses believes in the preservation of life, as most parasites do, so they will never be without a meal...

The idea of preserving and maintaining the life around you is an idea close to my heart. Ironically, we are conditioned to think of vampires as evil or destructive, when they really are the opposite. If they never kill the creature whose blood they drink, are they not more moral than a creature that kills to feed?

This painting had a long and unusual process, beginning with the sketches on this page and progressing to a large abstract pattern painted in full color right on the final canvas. This abstract served as my color guide, then the figures were drawn and painted into the "blobs" that were meant to be figures. As with most of my works, the sketches and final figures are drawn completely from my imagination. I believe one should be able to do this so that the imagination is never limited by a model. When I do use models, it is often to speed things along more quickly or to capture an exact likeness. Photos can also serve as great inspiration for poses and attitudes as well, but I rarely find 100% of what I am looking for, so I more often just make it up instead!

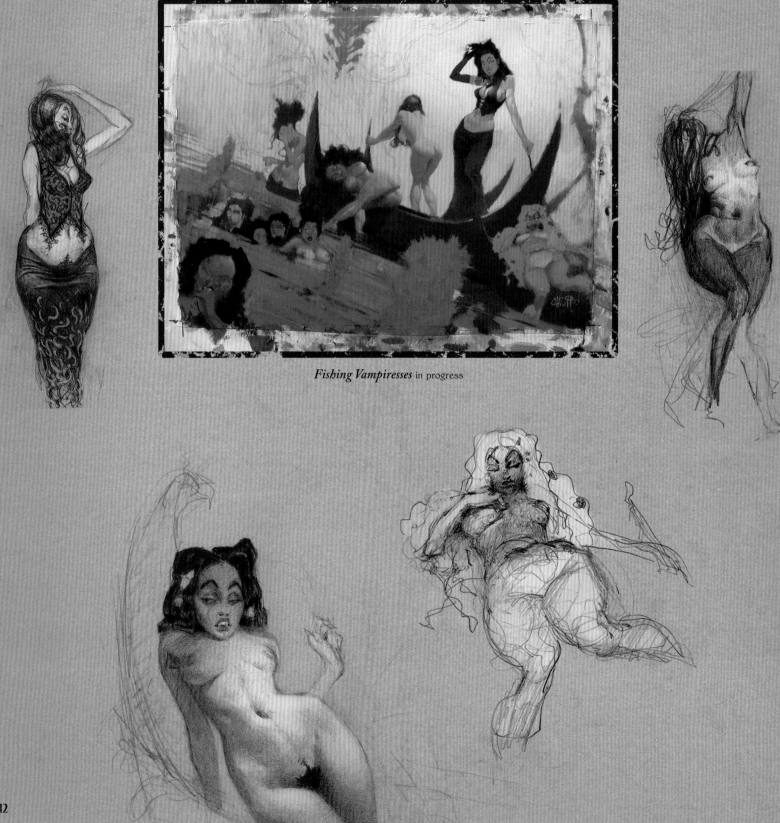

Fishing Vampiresses in progress

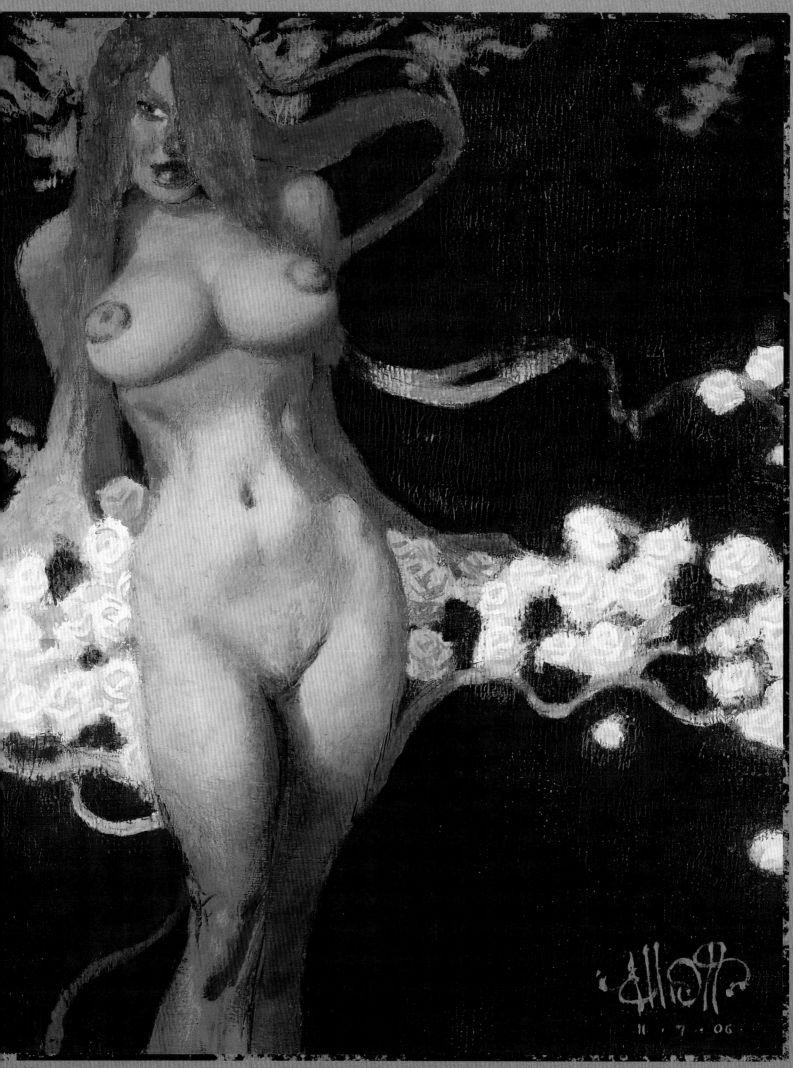

Flower Expanse (Opposite)

From the minute point of a seed, nature can expand to fill all the space around with life. Our thoughts follow the same path. From a small kernel of an idea, they can expand into amazing art, literature, medicine, discovery or technology...

This painting is a representation of two things that I believe are really the manifestation of one principle that seems to govern all life: The way Nature grows and the way our thoughts grow and form systems and stories are fascinatingly similar. This shows me that our thoughts and Nature are somehow one and the same, and that growth and a tendency toward complex systems is a fundamental part of the universe. It is even part of the human definition of life that it must grow to be called "alive." This is not to say that all growth is without cost or death. Death and growth are constant partners, and to deny that fact is to delude oneself about the nature of the universe.

I have seen this principle operate within myself and other individuals, as well as on large projects involving many people. The movies I have helped create have all grown in this way, each taking its own unique path. I count myself lucky to bear witness to the trail that path blazes, as well as the final product.

This painting, like several others, began without any preparatory drawings or model. I greatly enjoy the spontaneous creation that can come from starting without any over-planned road map to the final product. This is not to say that such an approach cannot be a great struggle either. I have many half-finished or abandoned paintings that were started this way. But, when it works, it is almost a magical thing. This approach seems to only have one of two outcomes: very satisfying, or no finished painting at all. I have learned to trust that when something is too much of a struggle, it is better to start over and put aside the one that isn't working. There have been times when the pieces I put aside were resurrected years later, after a solution to their problems came to me. This is why I save these experiments and don't paint over them or throw them away.

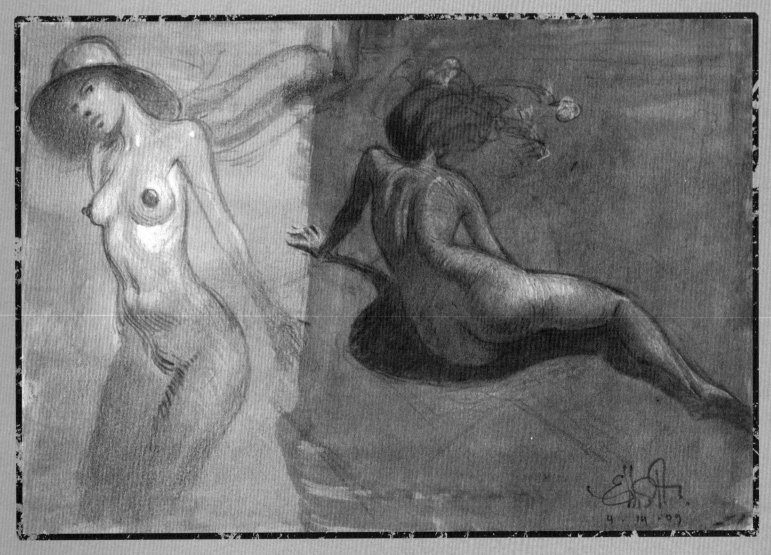

Color Sketches

I often draw on colored or toned paper. I learned this method from Harry Carmean, my teacher at Art Center College of Design. Harry uses ground-chalk pastels and rubs them into the paper. I do this as well, but also sometimes paint the paper first to tone it down and take the edge off the bright white paper. This approach feels more like painting for me, and can create a much shorter bridge between drawing and painting than drawing on white paper can.

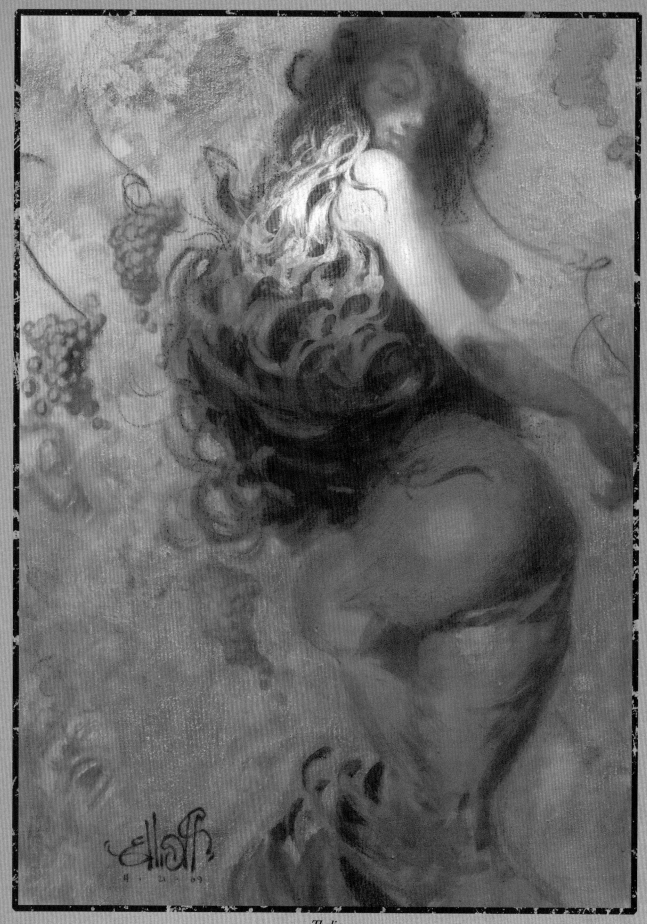

Thalia
Acrylic and pencil on mahogany panel, 8.5" x 11", 2009

Thalia

The goddess of all things rich and ample in the world, Thalia exudes a lush excess...

One of a pair of attempts at this painting, this was done as payment for a favor of a friend. Layers of acrylic and pastel created a series of translucent and opaque passages in this piece. The layers in acrylic are notoriously difficult to reproduce as compared to layers in oil paint. Some property of the chemistry in acrylic paint makes things that appear opaque to the eye actually transparent to the camera. This is one reason I have tried to work more often in oil, as many of my acrylic paintings do not reproduce as well.

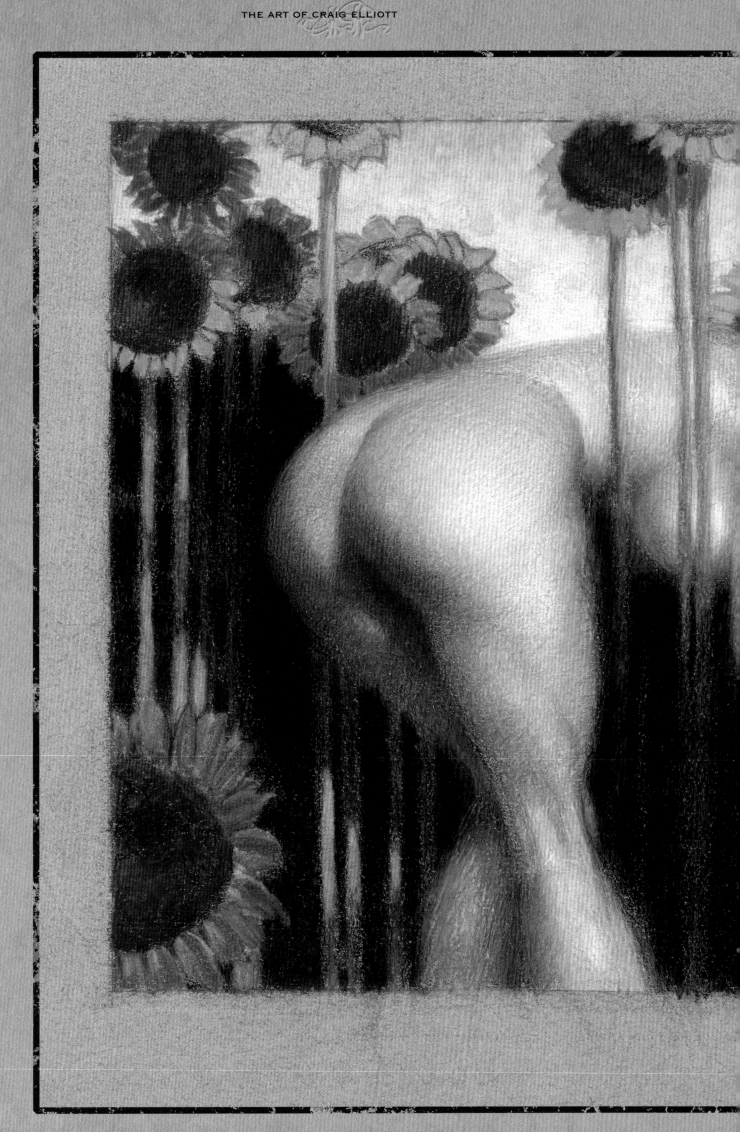

Fall Rising (Opposite)

The embodiment of fall begins her rise with the flowers and harvest of the season...

I enjoyed the challenge of creating a vertical feeling of rising within a contradictory horizontal format. This painting is part of a series, illuminating the phases of the seasons in female form.

The technique of this piece is one of the simplest in my collection: colored pencil on toned Canson paper.

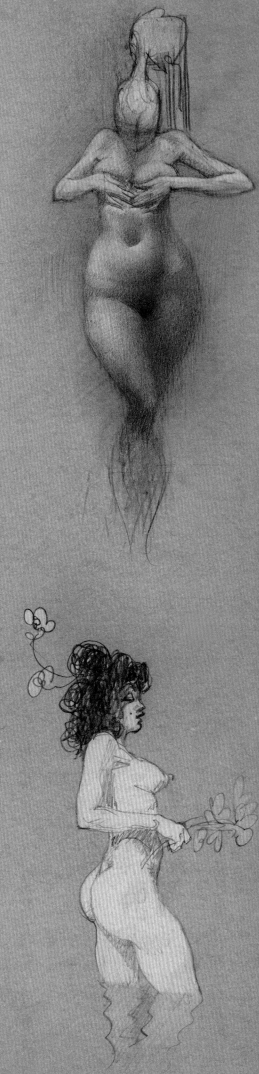

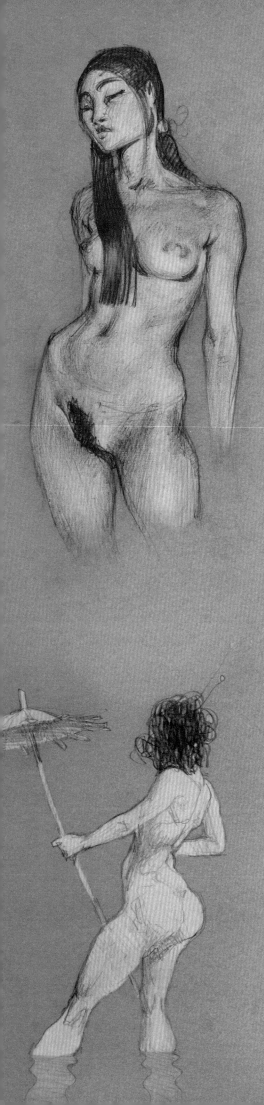

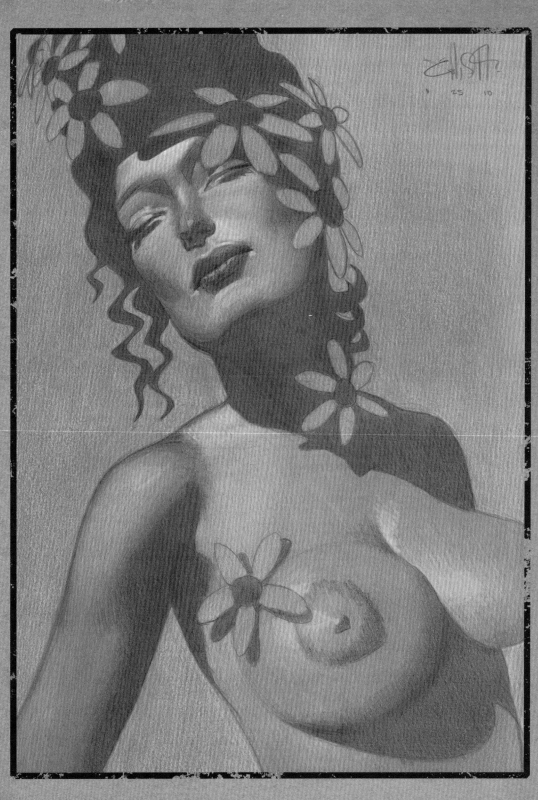

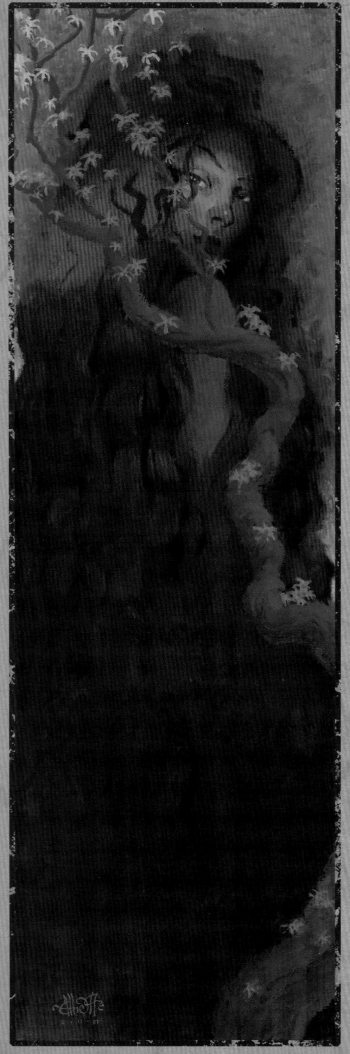

Forsythia

Her gaze is as shocking as the yellow bursts of flowers she is named for. Forsythia is at once direct and mysterious. She's hidden under rich red hair in the shadows, and yet her gaze is exposed by the light...

Forsythia is another idea that only came to fruition long after the original sketch. Ten years after the sketch, I finally did the painting. Starting with a large transfer of the original drawing, I added the branch for one more layer of mystery. Begun in washes of acrylic, the painting was finished entirely in thick oils whose strokes can even be seen here in the smaller reproduction.

Forsythia
Acrylic and oil on wood, 14" x 42", 2007

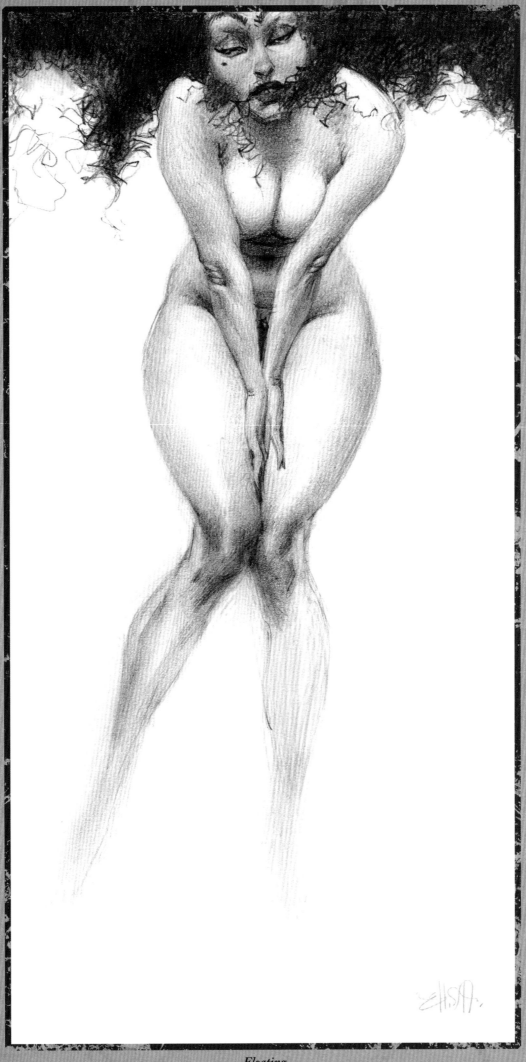

Floating
Graphite on paper, 4" x 8", 1999

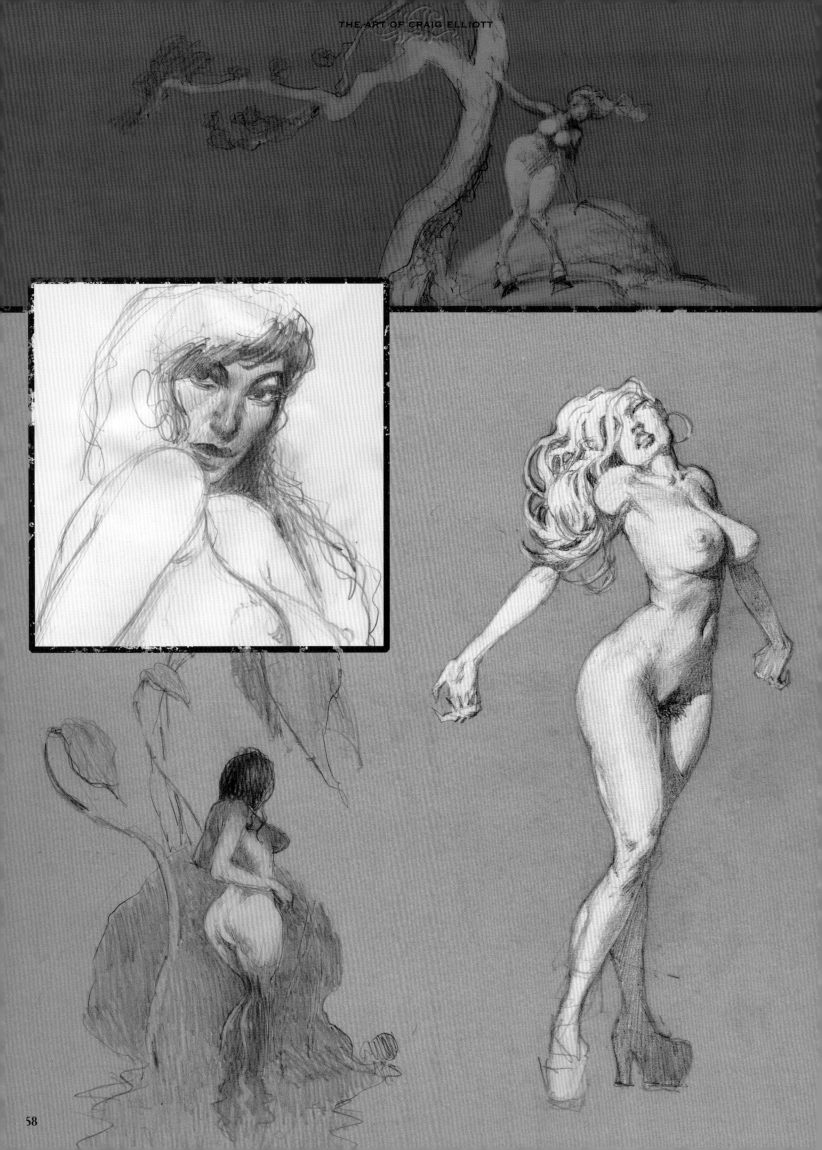

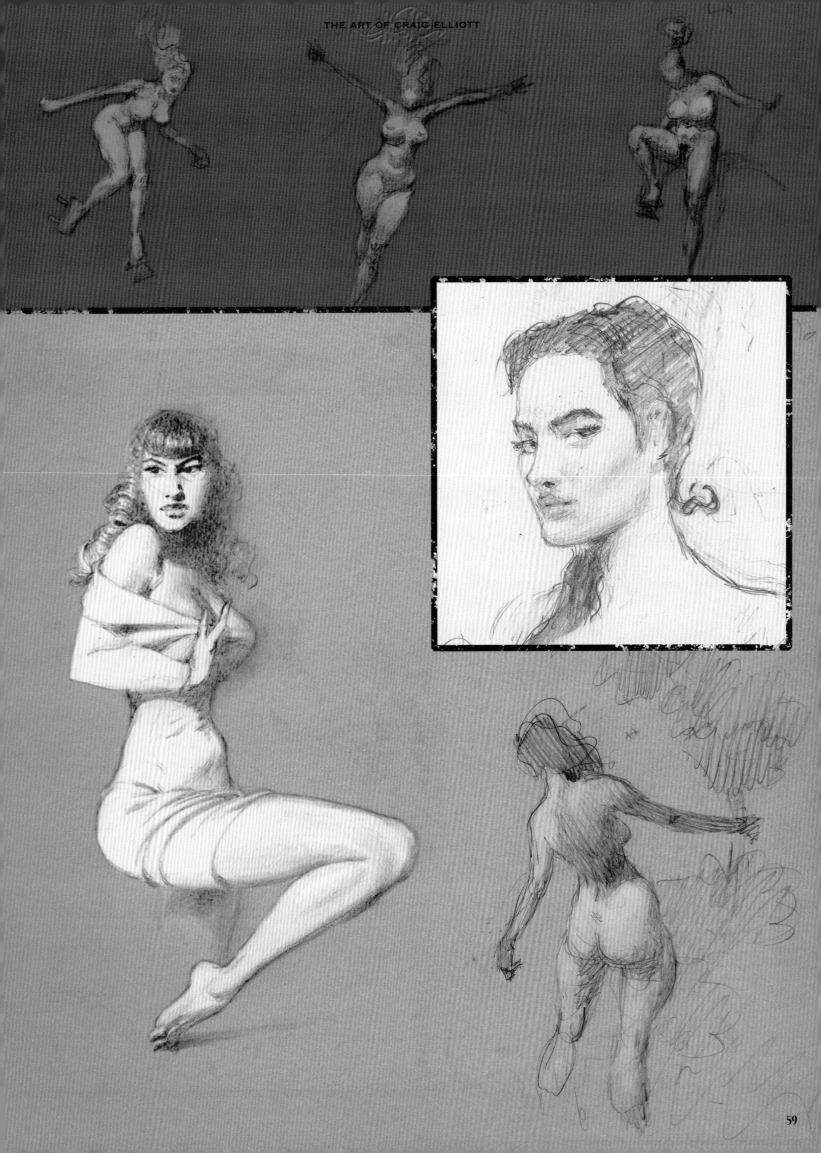

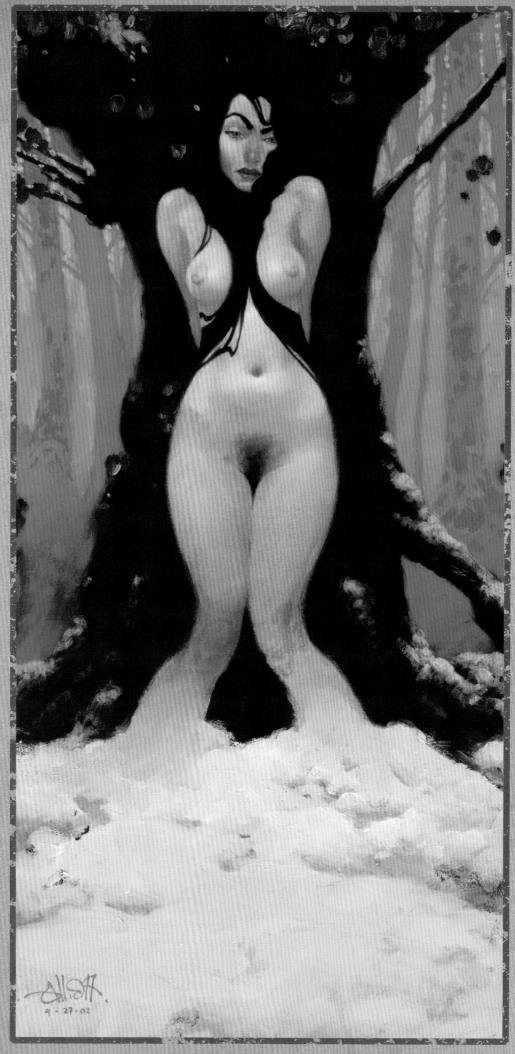

Winter Declines / Judith II
Acrylic and oil on illustration board, 13" x 21", 2002

Winter Declines/Judith II (Facing Page)

The beauty of winter fades and melts as her season gives way to spring—one form of beauty replaced by another. One season is not more beautiful than the last, merely different and unique...

After doing a graphite drawing on illustration board, I layered washes of acrylic over the body to give it the green and blue translucent hues. Her skin was touched up in places with oils, and the snow, tree and background were completed in oil. This is one of my few paintings based on a real person, Judy Wolf. This is where the dual title for this piece comes from.

This painting was my first entry into *Spectrum: The Best in Contemporary Fantastic Art* and made it into the unpublished category of volume 10.

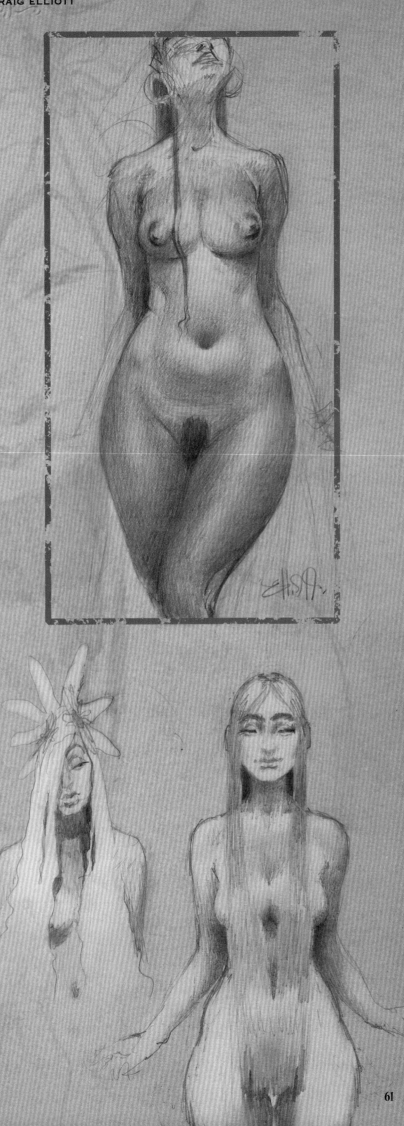

Original Sketch

The drawing underneath *Winter Declines/Judith II* was scanned before I started the painting. I wanted to capture the idea of the drawing before I "messed it up." Of course I think the final is much better in the end, and I never needed this scan to refer to or to transfer back onto the board. The accompanying sketches on this page are other takes on the same idea over the years. I may turn one or all of them into a painting someday.

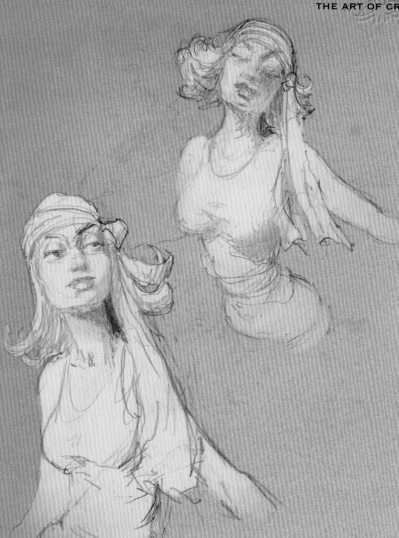

Life Drawing

Drawing from life is one of the most enjoyable activities I do as an artist. I enjoy learning the shapes and masses of a new person's particular features and body type. Far from just observation and recording of physical features, life drawing can capture a mood or personality. Some models are serious, some fun-loving, some wistful, some even enjoy acting and putting on little "skits" for the artists. Props and outfits often accompany the more performance-oriented models, and can really add to the fun of the drawing.

On these pages are a few drawings from female models that were done at Walt Disney Feature Animation while I was working as a visual development artist on *The Princess and the Frog*. These drawing sessions were supervised by Bob Kato, my former Art Center College of Design teacher. Bob still teaches at Art Center, conducts these drawing sessions at Disney as well as puts on his own themed drawing workshops in Los Angeles, called "The Drawing Club."

Bob has always been one of my favorite teachers, and I often tell him how much his lessons have helped me became a better artist. He is a humble guy and usually tells me he had nothing to do with me getting better, and that I could already draw when he met me. I don't know how this could be. I had to learn somewhere!

I am always learning and morphing the way I approach drawing to keep it fresh and interesting. Despite the variety of approaches I take, I still keep the elements of life drawing which I believe always ensure a great drawing.

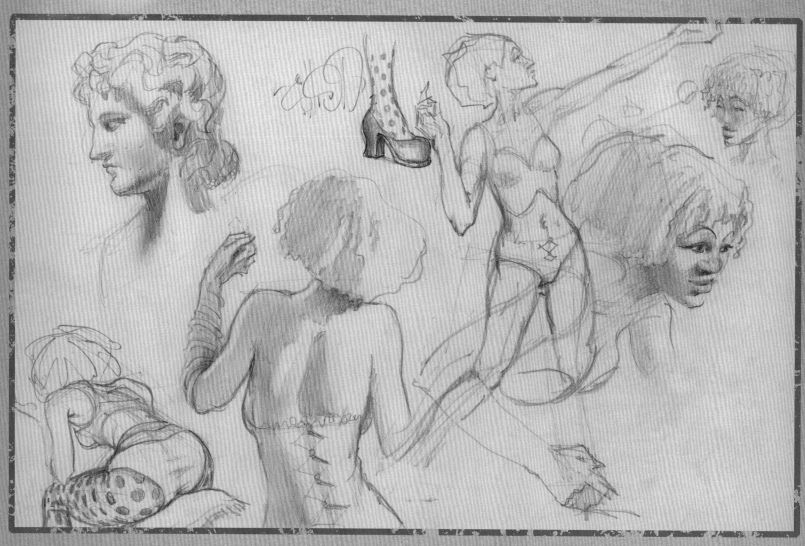

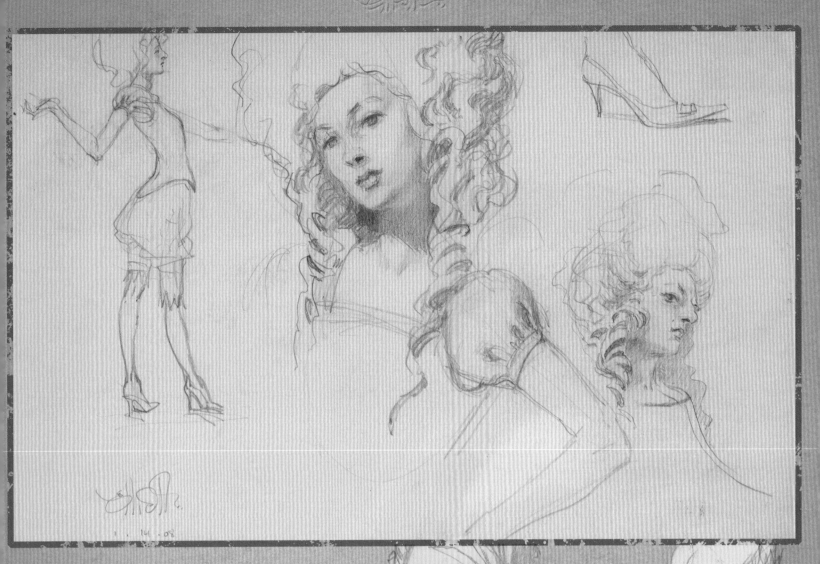

Great drawing has many elements, but the most important ones are always present in drawings that are compelling and artistic. The structural elements of drawing give it form and solidity. I always start by envisioning the bone structure first: This is the center around which everything else is built. Light lines can still be seen on some of these drawings, where I have drawn the bones of the legs and arms and things like the angle of the hips. After drawing this, I draw what is showing of the largest masses—the chest and hips. Then I proceed to the main masses of the legs, arms and head. Lastly, details such as the fingers, toes, hair and facial features are drawn. This "large to small" approach is important to help keep everything in proportion in the final drawing.

I have learned after doing many drawings that sketching what you see is really the act of observing something, then rebuilding it in your own mind and putting that on paper. When done well, it really isn't much like being a camera at all. I am not copying patterns of light and shade. Instead I am imagining solid shapes and then lighting them in my own mind as I draw. There is no better way to create a solid and very personal drawing.

The art that one injects into an image is the part of the drawing that is the most fun. Once the more academic elements of a drawing are handled, and even as they are handled, artistic touches are woven into the drawing. Things like a mood, a gesture or an action are elements that an artist builds on and exaggerates to add to the artistic content of a sketch. The model usually gives the suggestion of one or more of these things, and then the artist must take them and run with them to create great art. This is the essential kernel of the partnership between the artist and their model.

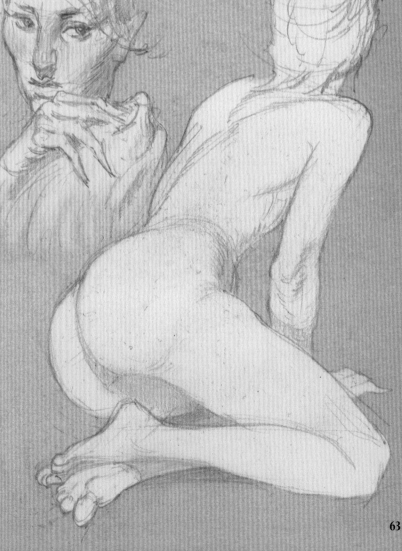

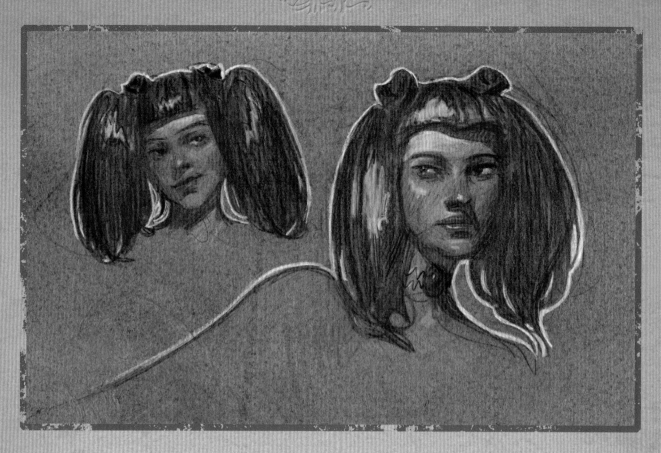

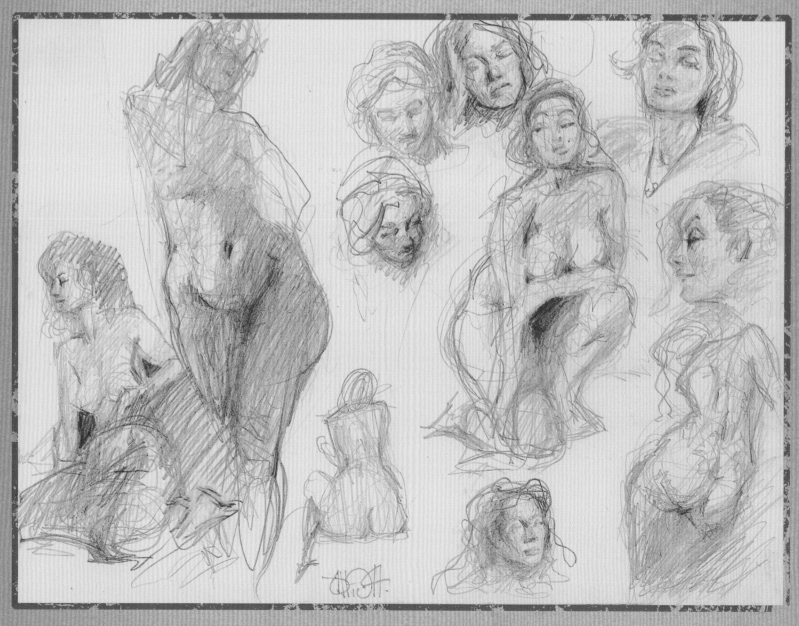

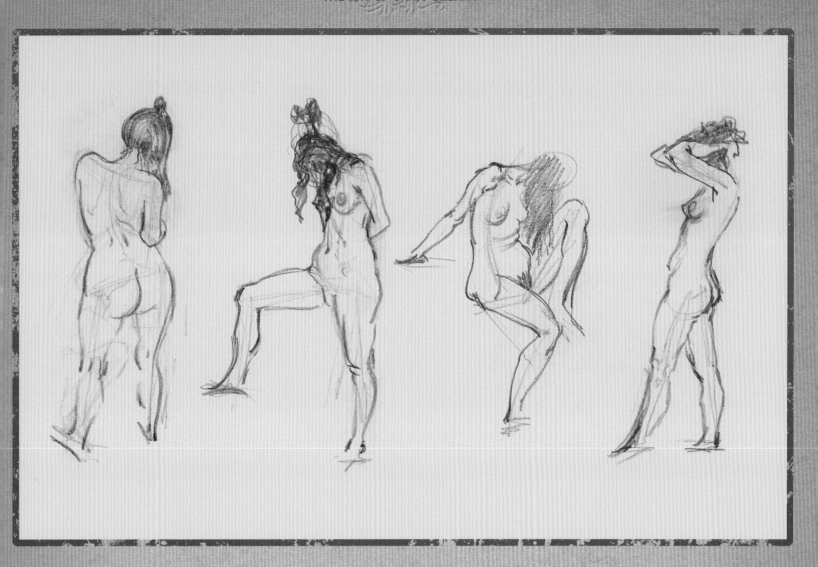

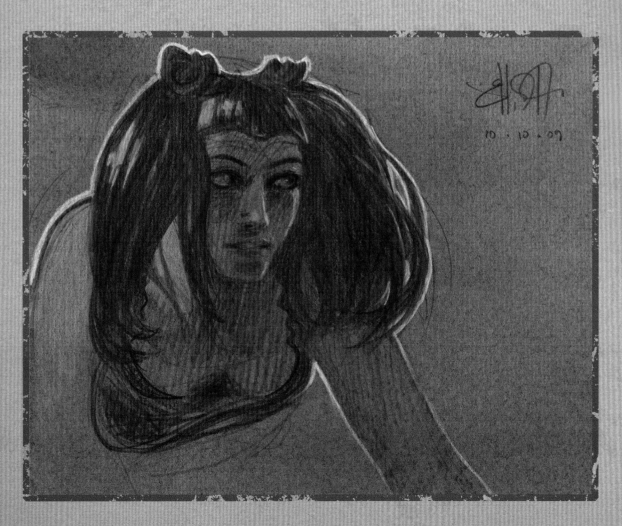

Music I

Music I is a piece that grew out of the batch of sketches I did for the *New Orleans Burlesque Poster* on page 37. I needed an image for a gallery show in Los Angeles that centered around poster/pinup style art. Since I had so many other designs I liked from the *New Orleans Burlesque Poster* project, I decided to adapt and redraw parts of one of those to design this piece.

The design was originally inspired by upbeat classical music and the feeling it gave me. I always envision a springlike vivaciousness when I hear that kind of music. I wanted to express the decadent energy of this music with the abundant and nearly sentient heap of blossoms twistin through the air to engulf the figure. The energetic wave in the background and the whipping stems of water lilies all combine to reinforce the themes of energy and life. In the first iteration of the design, there were musical notes in the air around the figure. I removed them, as they seemed too blatant a symbol for music. I wanted to express the feeling of the music rather than bother to make sure every single viewer knew the source of that feeling. The source doesn't matter much—it is the feeling that matters most to me. The design around the outside of the painting replaces the cast-iron railing-style design that was in the original. This design was meant to recall the cast-iron railings found on buildings in New Orleans. This original border design also had the same weight and energy as the daisy border in the final design.

Preliminary sketch

Taking one of the original roughs for the New Orleans poster, I further rendered and refined the figure and facial features. I needed to render the sketch more finely than normal since I wasn't using a model for this painting. A more refined sketch is a substitute for a model or a photo of a model when I am painting. I keep it next to me to refer to for lighting, form, gesture and paint-stroke direction. The center panel was part of the original drawing. I took this and worked up the border design on tracing paper laid on top of it. The two were combined in Photoshop, and the shadows on the flower mound were drawn in Photoshop. The border was drawn with vector drawing tools to be sure of its final accuracy.

Color comp

The color for this painting was determined in a few layers of sketching in Photoshop. Most of the sketches like this are painted in one layer: I find it faster to do this than to have to remember what part of the image is on what layer. If I try to keep things separate, I inevitably seem to forget what I am doing and start painting on the "wrong layer." I think I just get so focused on the color and design that it is too much for me to also remember where I should be putting that color. I make fixes all over the painting at once and don't focus just on one thing at a time. This way of jumping around is necessary, though, as a color is always relative to the other colors around it. A slight change in one color can change the perceptions of all the other colors.

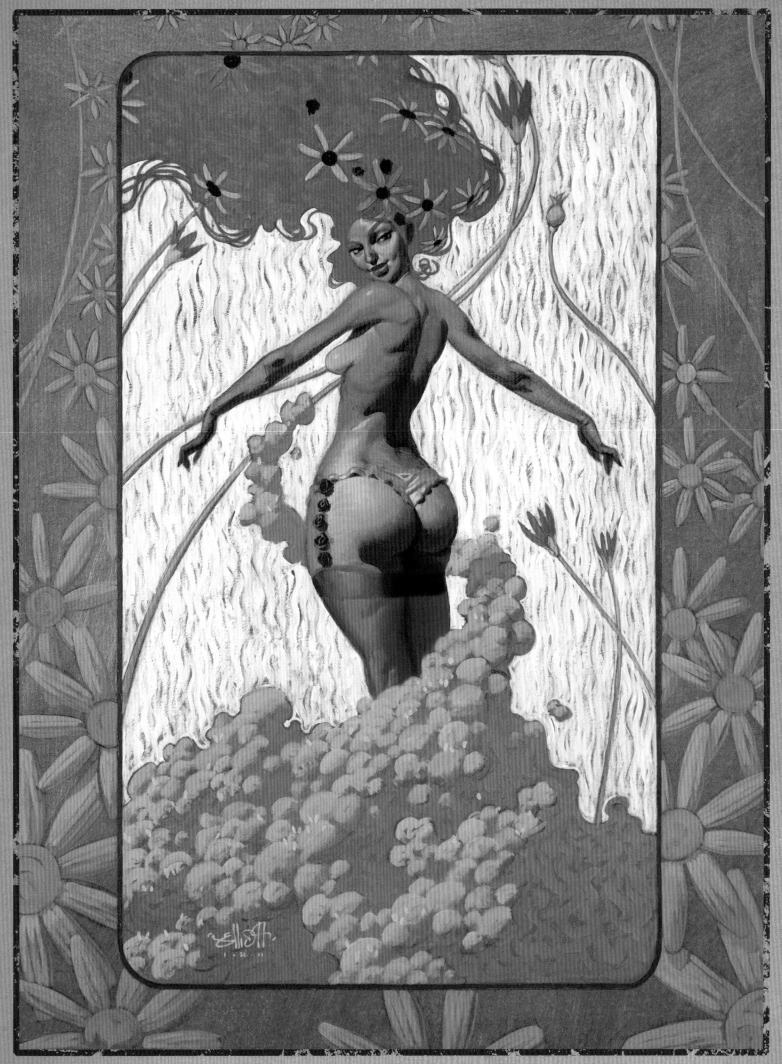

Music I
Oil on Rives BFK paper, 16" x 24", 2011

WHERE TO FIND THE ART OF CRAIG ELLIOTT

Signed prints, books, original art and more available at:
www.craigelliottgallery.com

Fine precious metal and stone jewelry by Craig Elliott available at:
www.craigelliottcollection.com

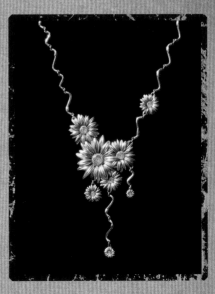